DAWLI[
TEIGNMOUTH

From Old Photographs

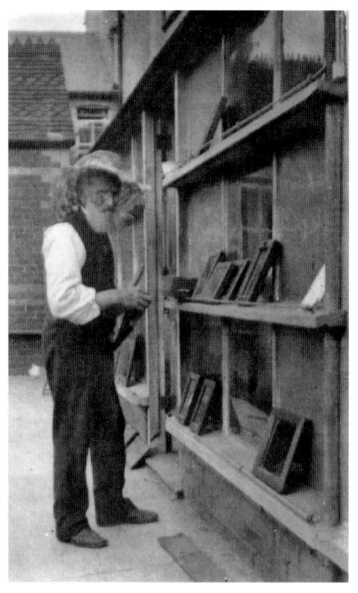

William James Chapman placing photographs outdoors in order to print them by exposure to sunlight, *c.* 1908. He was born in Exeter in 1830 and, after being employed in the family dyeing business, moved to Dawlish in 1863 where he opened a photography business at the top of Town Tree Hill, later moving to No. 20 Regent Street, where he was joined by his son, William Samuel. By the 1890s they were running a small industry in plush goods; these consisted mainly of trinket boxes made from cardboard and covered with plush, with a photograph of a local scene mounted under glass for a lid. By 1907 the popularity of plush goods was waning but postcards were becoming popular, so the business was adapted to their production, the firm gaining a reputation second to none in this field in the West Country. William Samuel Chapman died in 1918, but his father lived on until the age of 93 in 1923 and, in turn, his grandson, Stanley William, and then his great-grandson, Bernard, ran the business until its closure in 1966. Bernard Chapman collected a vast number of photographs of Dawlish and its people, many of which will be seen in this book.

DAWLISH & TEIGNMOUTH

From Old Photographs

GERALD GOSLING

AMBERLEY

For the staff, past and present, at Langdon Hospital;
and especially June, Jackie and Mitzy.

First published 1993
This edition first published 2011

Amberley Publishing
Cirencester Road, Chalford,
Stroud, Gloucestershire, GL6 8PE

www.amberleybooks.com

British Library Cataloguing in Publication Data.
A catalogue record for this book is available from the British Library.

ISBN 978 1 4456 0034 5

Typesetting and Origination by Amberley Publishing.
Printed in Great Britain.

Contents

Introduction 7

1 Dawlish 9

2 Teignmouth 31

3 The Villages 57

4 At Work ... 79

5 ... and Play 95

6 High Days 117

7 Beside the Seaside 129

8 Transport 143

Acknowledgements 160

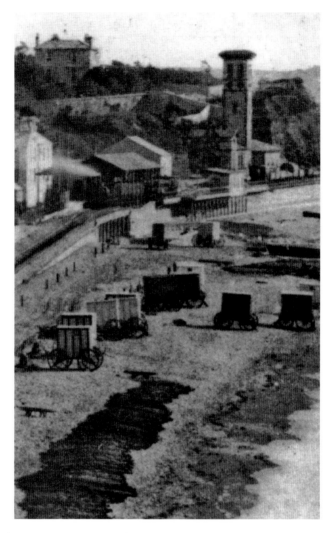

The first Dawlish station, *c.* 1868, with a train hauled by a typical South Devon saddle tank locomotive; the coaches, probably four-wheelers, have flat roofs. The freight vehicles in the distance include a high, covered 'bonnett' wagon typical of broad gauge stock. The atmospheric pumping house and tower was built in 1846-7 by Brunel in the design of an Italian Campanile. This station, which was destroyed by fire in 1873, was built in 1846 when the Bristol and Exeter Railway, which had reached Exeter in 1844, extended its line along the west bank of the Exe to Dawlish Warren and then along the coast past Dawlish to Teignmouth. Brunel, their chief engineer, decided to install an atmospheric system; trains using this method did not need a locomotive to provide the hauling power, instead a flat-topped wagon called a piston carriage was used. A cast-iron pipe about 15 inches in diameter was laid between the rails inside which a piston travelled, attached by a bar to the underside of the piston carriage. At about three mile intervals, pumping stations were built; they exhausted the air in front of the piston so that the atmospheric pressure behind pushed it forward. When a train was due, the pumping stations sucked out the air in front of it, and stopped pumping as soon as the train had passed. The system was not a success; leathers used to make the pistons air-tight deteriorated, some say the rats ate the grease used as a preservative as well, and it was abandoned on 9 September 1848. The pumping station at Starcross is still standing and has been turned into a museum.

Introduction

The English Riviera has many jewels in its crown, none more valuable than the twin towns of Dawlish and Teignmouth. But to call them twins is misleading; they are as different as chalk and cheese. Dawlish, quieter, elegant, unique with its railway line running along the sea front, is as graceful as any seaside town in the realm. Teignmouth, elegant in its way, and with Shaldon and Ringmore beckoning across the estuary, is more work-a-day with its harbour and ancillary trades but, like Dawlish, it has much to attract the holiday-maker, both of day-tripper and long-stay variety. And, if you tire of the sea and sand, and who doesn't, both towns are backed by the superb countryside of Devon at its very best, Dartmoor beckons behind the Haldon Hills, Powderham Castle, the home of the Courtney Earls of Devon, is on one doorstep, Torquay and Torbay on the other.

Dawlish's big attraction, apart from the sea, is The Lawn; that beautifully grassed area right in the centre of the town with its stream, ducks and the town's distinctive black swans. Here the town's handsome buildings crowd down to but never seem to be part of the scene. At Teignmouth, away from the bustle of the sea front, the tiny back streets, especially near the river and the harbour, are packed with interest and something new can be found around every corner.

But there is an older Dawlish and Teignmouth. At a time when man made his own amusement, travel beyond the confines of his town was an event which, like the high days of coronations, jubilees, fêtes and parties, was looked forward to for weeks beforehand and then talked about for weeks afterwards. For all its limitations – possible poverty for

many, which all too often led to the dreaded workhouse, and lack of the things we take for granted today (like good sanitation, holidays abroad, TV sets, washing machines and comprehensive, advanced medicines, longer lives if shorter tempers) – there was a quality about life then that is missing today. Children could and did talk to strangers in the street; you could leave a bicycle unlocked almost anywhere, secure in the knowledge that it would be there when you came back, neighbours knew and helped each other in shared times of trouble and, more often than not, few doors were locked.

Many of the pictures in this book show the Dawlish and Teignmouth of those times, smaller, more self-sufficient and, dare it be said, happier. If they give happiness and pleasure to today's generation, the labour in compiling them will have been worthwhile.

Gerald Gosling
1993

one

Dawlish

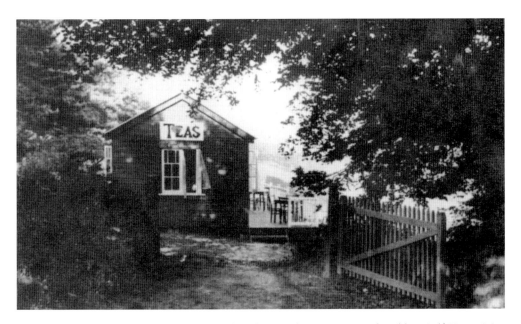

The Haldon Tea House, *c.* 1936, where the lane from Bishopsteignton and Haldon Golf House joins the Teignmouth-Exeter road. Today it is a private bungalow.

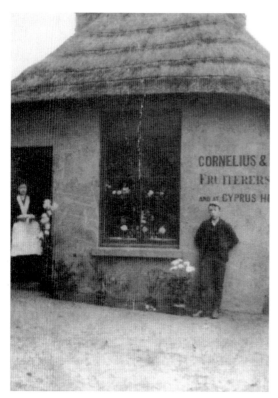

Cornelius & Son, fruiterers and florists, at the foot of Teignmouth Hill, Dawlish, with Mrs Cornelius in the doorway, c. 1870. They also had a shop at Cyprus House in High Street. This delightful thatched building was later demolished and the site is now part of the National Provincial Bank.

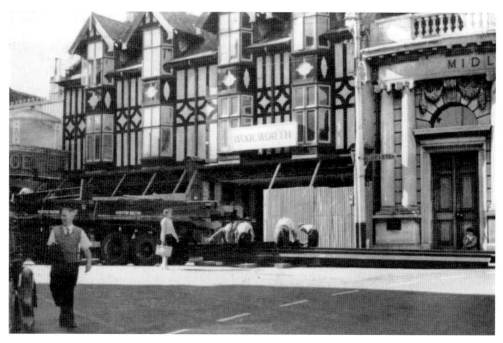

Construction work in 1956 at the end of The Strand, Dawlish, where a Woolworths branch was to replace Brunt's Café.

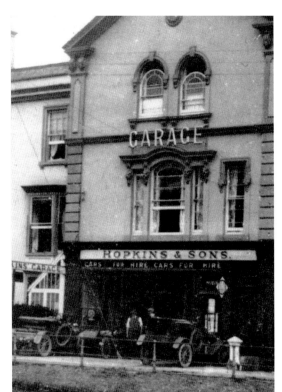

Hopkins & Sons' garage, Piermont Place, Dawlish, *c.* 1915. In later years it became the coach station and main booking office of Greenslades Tours Ltd. Greenslades, who ran day, half-day and evening excursions throughout the West Country, and also had either branch booking offices or agents at Dawlish Warren, Starcross and Kenton, were taken over in the 1960s by the Southern National Bus Company.

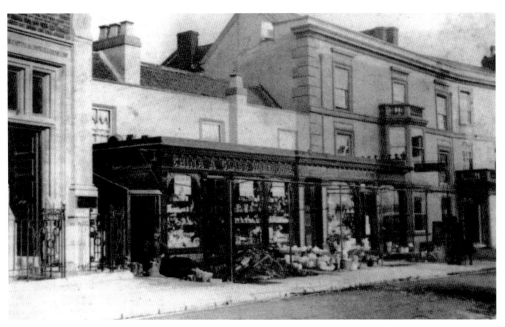

J. Shapter's florist, poultry and dairy shop in The Strand, Dawlish, *c.* 1890. In the middle of the nineteenth century the Shapter family had been in the building business in Dawlish. Later they turned to motor cars and these premises became G.C. Shapter's Garage. Today it is the Gateway supermarket.

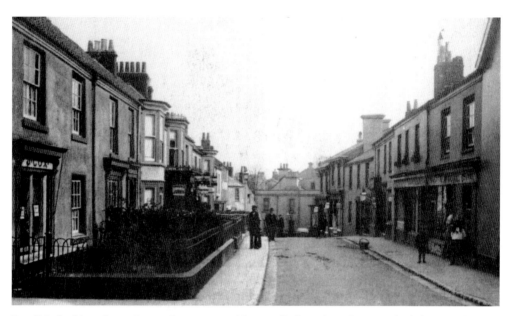

Dawlish, looking down Queen Street, 1908. The small, fenced gardens on the left were there as recently as 1965 when they fell victim to a road-widening scheme. Moore's Stores on the right is now Taylor's greengrocers; the supermarket and fish and chip shop are now on the left. Just visible at the bottom and looking up the street is the house which became the Scala Cinema (see p. 82) and is today Barclays Bank and the town library.

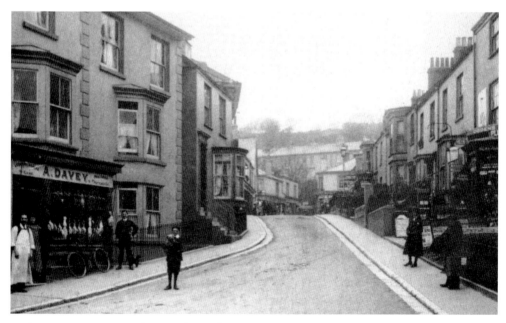

Looking up Queen Street this time but still in 1908. Note the bare skyline behind, where much of Stockton Hill area development has taken place in recent years. On the left, Davey was a poulterer of some repute.

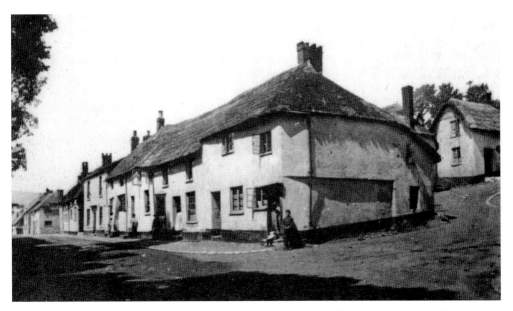

Old Town Street, Dawlish, 1870. The building at the back was the first of these lovely old cottages to go; now they have all gone and the site is occupied by old people's flats. Tucked in the middle and out of sight was the Red Lion, once one of fourteen inns in Dawlish but, like the cottages, sadly no longer with us.

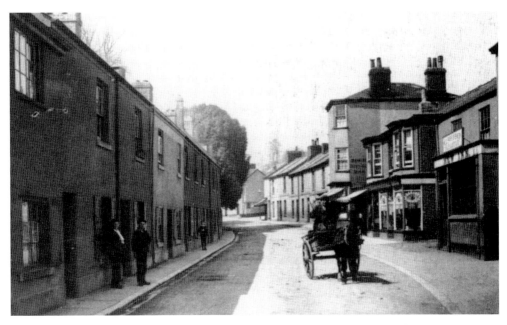

Old Town Street, Dawlish, 1908. The New Inn has long-since gone, of course. It became Mrs Davis's grocery shop in the 1960s and is still a grocery shop.

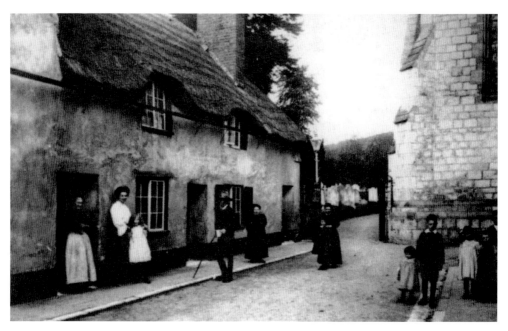

Church Cottages, Dawlish, 1907. The cottages were demolished following a fire in 1913 (see below) and the War Memorial stands on the site today.

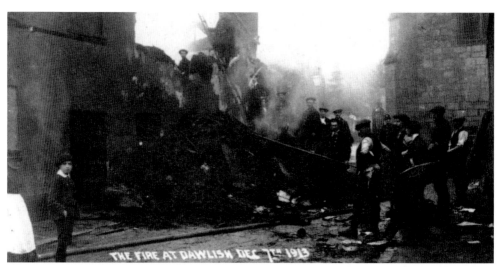

THE FIRE AT DAWLISH DEC 7TH 1913

The fire at Church Cottages in 1913, which, owing to its nearness to the parish church, gave much cause for concern at the time.

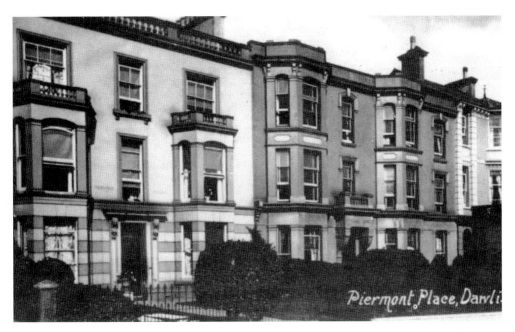

Piermont Place, Dawlish, *c.* 1910. Then a highly respectable and imposing row of Victorian buildings, erected when Dawlish finally reached the sea, by the late 1960s amusement arcades and cafés were taking over. Today the area caters almost exclusively for the tourist trade.

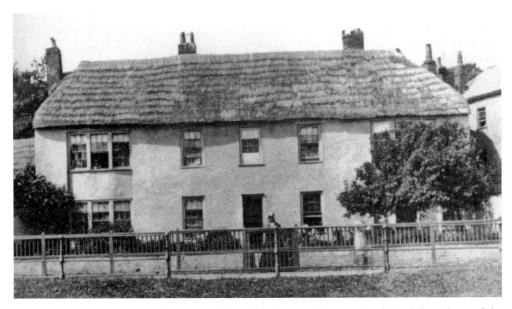

Brookdale, Dawlish, *c.* 1860. This is one of the oldest known photographs of Dawlish, and one of the most interesting. This attractive building was knocked down to make room for Brookdale Terrace; imagine the howls of wrath that would greet such an action today – and rightly so. The grassed area in the foreground is now part of the putting-green.

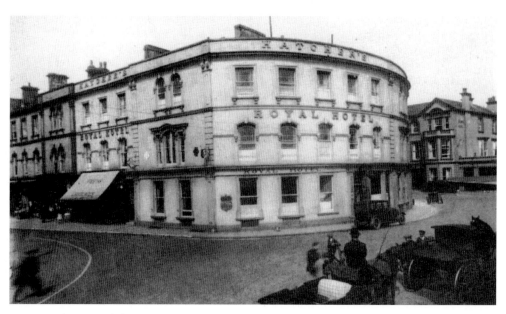

Piermont Place, Dawlish, *c.* 1936. Compared to the picture on page 15, the commercial growth in the area can be plainly seen. Main interest, however, is centred on the two horse cabs, the last ones to operate in the town. At the time of writing, the work of demolishing the Royal Hotel has been in limbo for nearly two years and the crane used is a seemingly permanent, and unwelcome, part of the Dawlish skyline.

The Lawn, Dawlish, 1923. This view of the upper end of The Lawn, taken from Brunswick Place, shows the bowling-green with a game in progress, but is taken just before the pavilion was built.

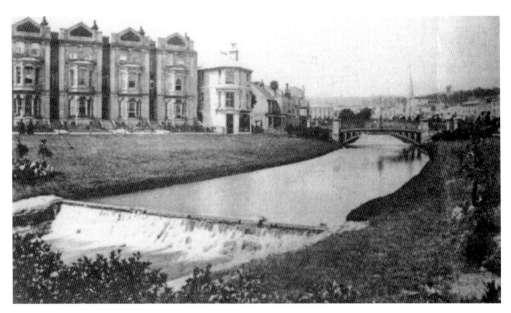

Tuck's Plot, Dawlish, before 1881, later the York Gardens (see below). Brookdale Terrace is in the background.

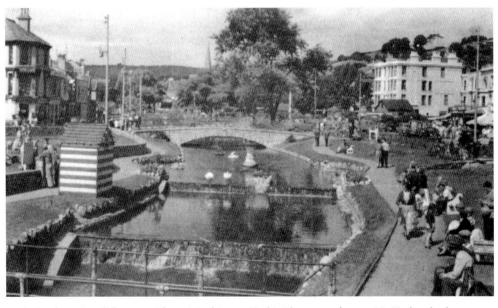

York Gardens, Dawlish, 1961. The original name, Tuck's Plot, came from a Mr Tuck, who kept some baths at the bottom of nearby Teignmouth Hill and had used the area as grazing land for his horse (without permission). The present fountain was built in 1881 by Richard Early and the old iron bridge, seen in the picture above, was replaced by today's stone bridge in 1887. In 1899, anxious to give the area a 'better' name, Dawlish Council chose York Gardens from a list that included Marine Gardens, Piermont Gardens, Tinker's Mead, Perfection Park (?), The Swannery, Paradise Gardens and Victoria Gardens.

Barton Lane, Dawlish, *c.* 1908. People need houses, but few will compare, without a tinge of sadness, the Barton Lane of today with this quiet and charming view around the turn of the century, when it was obviously a popular walk for locals.

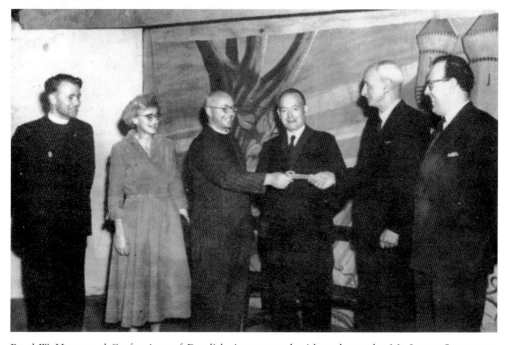

Revd W. Hammond-Croft, vicar of Dawlish, is presented with a cheque by Mr Laxon-Sweet as a farewell present before he left the town in 1955 to become the vicar of Alphington, near Exeter.

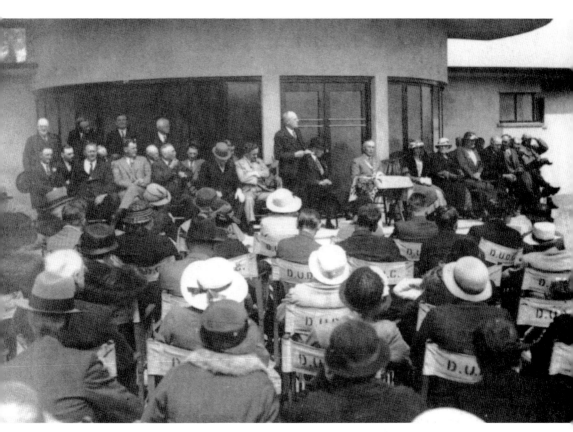

Dawlish playing field pavilion was opened on 27 May 1935. The constructors, the Astolant Company of Guildford, entertained the Council to lunch. At the opening ceremony that followed, Mr F.G. Avant-Washington, chairman of Dawlish UDC, seen here speaking, said that he and some of his colleagues on the Council had succeeded in the face of considerable opposition in retaining some of the Pidgley estate for a recreation field. Of the rest of the land, 12 acres of the higher land would remain as open space for all time, 8 acres had already been sold for a senior elementary school and the rest was to be developed as building land. Opening the pavilion with a golden key, Lord Mildmay (Devon County Council) said he would do all he could to support an application for a grant to complete the facilities.

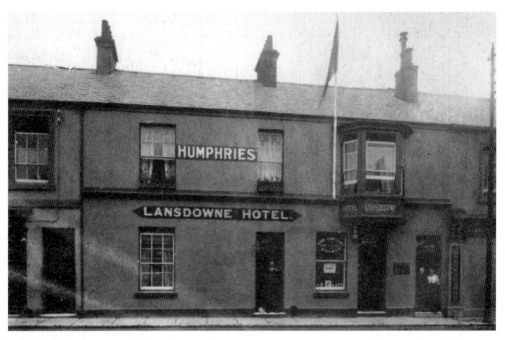

Humphries' Lansdowne Hotel, Park Road, Dawlish, *c.* 1915. The hotel is little changed today but it is now flanked by the offices of the *Dawlish Gazette* and Mrs Jane's sweet-shop.

The London Hotel, The Strand, Dawlish, *c.* 1900. This handsome hotel was bought by the Council in September 1910 so that the main road into Dawlish from Exeter could be widened. The width of the road at the bottom of Strand Hill and Iddesleigh Terrace was only 12 ft at the time; after the alterations it was 24 ft. Today Woolworths and Midland Bank occupy the site.

The Hut, Barton Hill, Dawlish, 30 May 1959. The Hut, seen here early on the last morning of its existence, was for many years the social centre of Dawlish. Once an Australian Army YMCA canteen in Sutton Viney, the building was brought to Dawlish by Charlie Ross, who intended it to be an entertainments centre and installed a billiards table, a grand piano and a mustel organ there. Messrs J.H. Lamacraft installed, renovated and redecorated it at a cost of around £500. It opened on 16 December 1920 and could hold as many as 700 people. During its thirty-nine-year life it staged hundreds of shows, dances, concerts, pantomimes and other functions and was used by the local Home Guard in the Second World War. Despite bad acoustics, a wood-plank floor that was not up to 'Come Dancing' standards, a too-small stage and far-from-perfect audience viewing, the Hut is still warmly remembered by the generations of Dawlishians who grew up with it. The Hut eventually became dangerous and was demolished and today is the site of a car park.

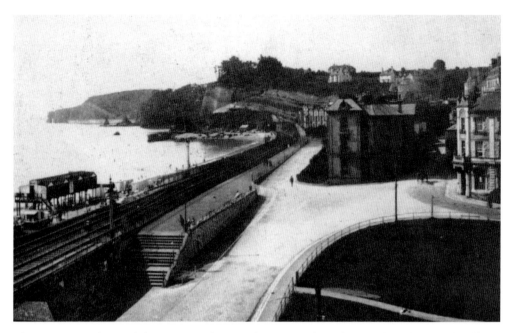

The Marine Parade, Dawlish, *c.* 1920. Of interest here, apart from the complete absence of traffic, is the old viaduct under which access was gained to the beach. It was altered in 1927 and the shelter for cabmen erected.

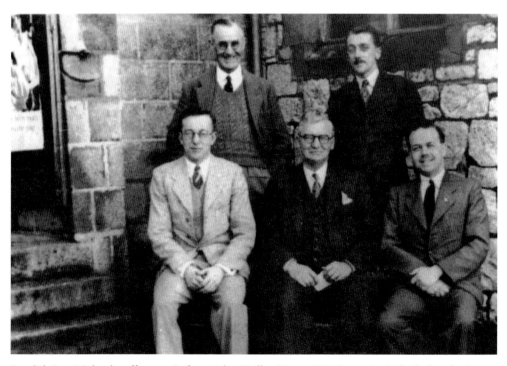

Dawlish Boys' School staff, 1934. Left to right: Hedley Hoare, Eric Fountain, Jack Shobrook, George Lamacraft (headmaster), Brian Crispin.

Dawlish, *c.* 1913, from Barton Lane, which was always known as 'Back Bartons'. Note the fine show of trees on the hill behind, long since felled to make way for development (see below).

The junction of Hatcher Street and Stockton Hill, Dawlish, *c.* 1929. Taken looking up Stockton Hill, this photograph shows the trees seen in the picture above shortly after they had been felled.

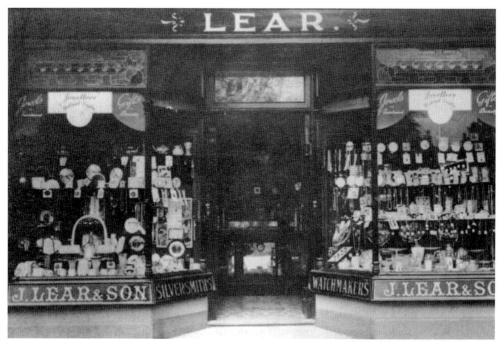

J. Lear & Son, jeweller, The Strand, Dawlish, *c.* 1937. Holman's bakery (see below) moved to the premises, which later became part of Hill, Palmer and Edwards' Restaurant. It is still a restaurant today.

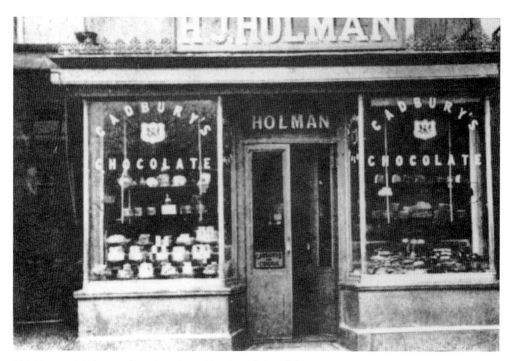

H.J. Holman's bakery at its original site, The Strand, Dawlish, *c.* 1910.

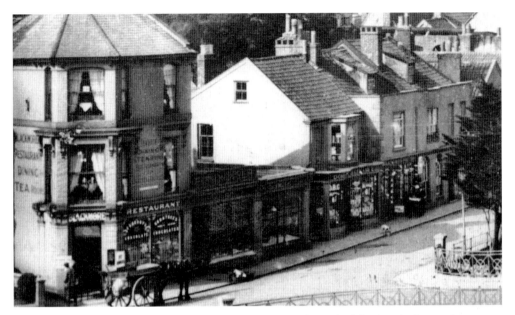

The sea front end of Brunswick Road in 1912, showing, from the left: the Blackmore Restaurant (later H. & B. Capener's gift shop and Mrs Butler's York Café), Dart's fishmonger shop (later Tarr's), Smith's poulterers (later Peyton's shoe shop), and the Domestic Bazaar – 'nothing over 6½d' – (later Soundy's outfitters).

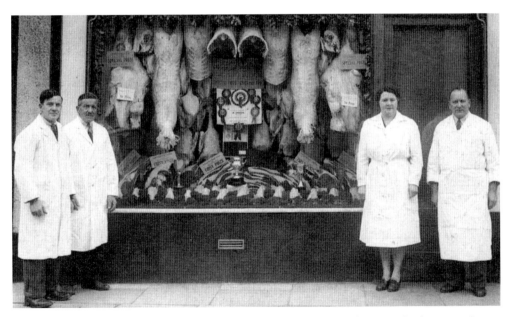

H.G. Thorp, Family Butcher, Old Town Street, Dawlish. The 1951 Christmas display centred on a champion bullock purchased at Smithfield by Herbert Thorp, who is seen on the right with his wife, Elsie; his brother, Percy, with his son, Brian, is on the left. The Thorp family purchased the well known business from Mr Pike in 1931 and it is still run by the family today, enjoying a reputation second to none in the area.

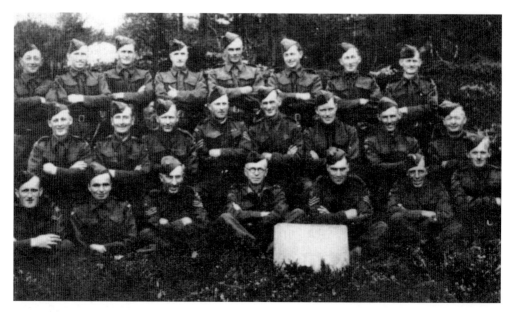

Home Guard, Dawlish, *c.* 1943. The 'Haldan Commandos' were formed in case of an enemy landing on Haldon Moor, the high land behind Dawlish and Teignmouth, and were a specialist unit trained for the laying of mines and demolition work. Among the members here are Maurie Penaligon, Norman Rowe and the Goodridge brothers, Jeff and Fred, who later farmed at Dawlish Warren.

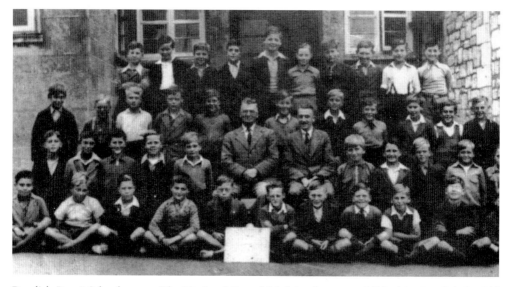

Dawlish Boys' School, 1934. The National Parochial School was established in Dawlish in Old Town Street in 1819, and by 1869 had 130 pupils (90 boys and 40 girls). Around 1863 a new boys' school was built higher up the hill for 200 pupils; the girls and infants continued to be taught in the old buildings, which were enlarged in 1898. In 1937, the Old Town Street school was converted for the use of infants only, all children over eight being taught at the boys', school. George Lamacraft, headmaster at the time, is seen here with the class master, Eric Fountain. Among the boys are Ken Baker, Micky Franks, George Lambshead and Syd Underhill.

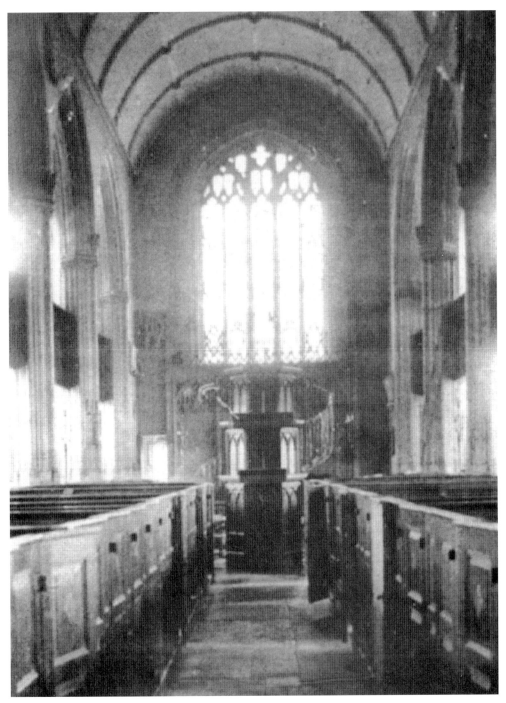

St Gregory's church, Dawlish, before 1875, when extensive alterations were carried out both inside and outside. The handsome, if overbearing, box pews and the triple-deck pulpit were replaced, the floor lowered, and a fine east window much altered (although not necessarily improved).

St Gregory's church, Dawlish, seen here again before 1875, when the alterations were made. Outside they included all the rough plaster being removed and the pinnacles and battlements taken down.

The Red Lion, Old Town Street, Dawlish, *c.* 1925. This handsome pub lost its thatch in 1932. Later it also lost the distinctive inn sign on the edge of the pavement. The pub itself was finally demolished, although not until the end of the 1980s, when it made way for development. Happily its name is not lost to the town, as part of that development is known as Red Lion Court.

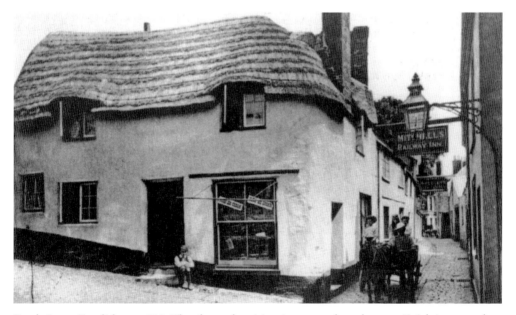

Beach Lane, Dawlish, *c.* 1888. The shop advertising ice cream later became Knight's sweet shop and then a fish shop owned by Bill Dart. The Railway Inn's sign shows that a Mr Mitchell was the landlord at the time; he was followed by Mr Eveleigh. Just visible a few yards down the lane is the Exeter Inn. Shortly after this picture was taken, the slope in front of the shop was levelled and steps to both the shop door and the top of the lane were built.

Barton Crescent, Dawlish, *c.* 1908.

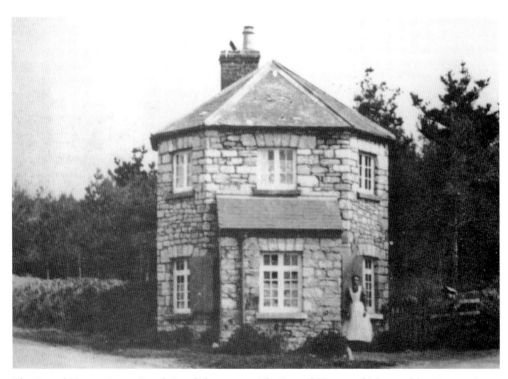

The Round House, Exeter Road, Dawlish, *c.* 1910. The Round House, which stood by Warren Copse at the junction of Exeter Road and Warren Road, was once a toll-house. It became a private residence and was demolished in 1936.

two

Teignmouth

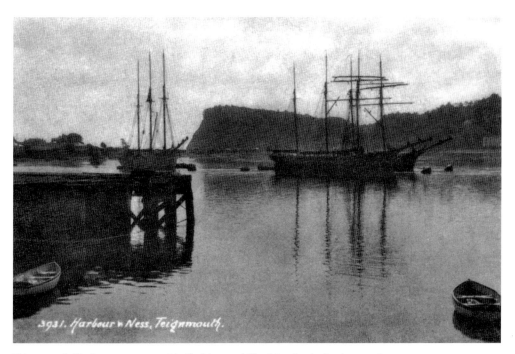

Teignmouth Harbour, *c.* 1925, with Shaldon and The Ness in the background.

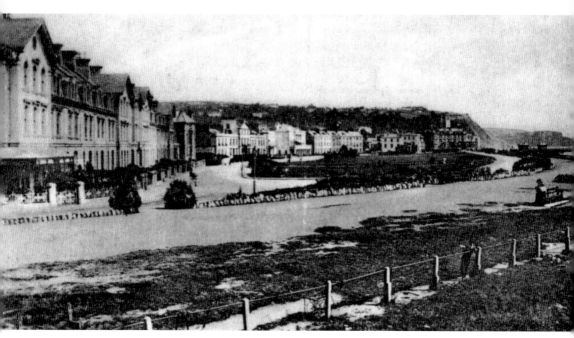

The Den, Teignmouth, *c.* 1902.

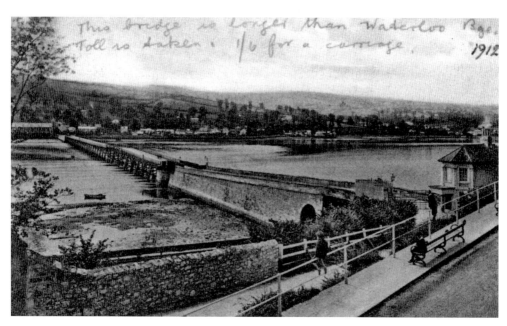

This bridge is longer than Waterloo Bge.
Toll is taken : 1/6 for a carriage.
1912

The old wooden Toll Bridge, Teignmouth, 1912. The bridge was erected in 1827 and took the B3199 over the Teign estuary to Shaldon and Torquay. It was replaced with the present bridge in 1931. The tolls were removed as late as 1948 when the Teignmouth & Shaldon Bridge Company sold the bridge to Devon County Council. The Council allowed the last gateman, Edward Tucker (see p. 35), to continue living in the toll-house (on right) as an act of kindness in view of his age (64 years). They were kinder than they thought; he lived on there until he was 93!

The eight Dyer children, left to right, Carol, Harry, Rosina, Jack, Sonny, Ida, William and Gladys, at their home in Higher Brook Street, Teignmouth, *c.* 1920. Their father, William Dyer, had a stabling business in the town.

The Tea Gardens (Coombe Cellars), Teignmouth, *c.* 1910. Overlooking the river, this was a popular spot at the time. The menu included local cream and fruit. For the gourmet the lobster tea at half a crown was a must.

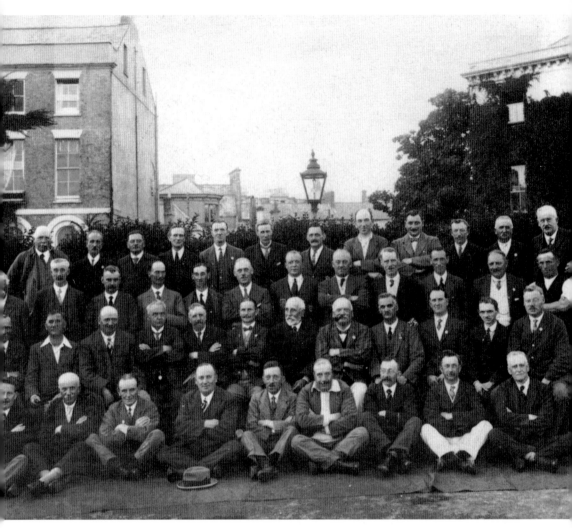

Jack Clampit, in shirt sleeves on the extreme right of the second row from the back, was greenkeeper at Teignmouth Bowling Club for many years. The esteem in which he was held can best be gauged by the number of people who contributed to his benefit in 1921, some of whom can be seen here in the grounds of the Courtney Hotel (right background and now flats). The building on the right is today's Royal British Legion Club.

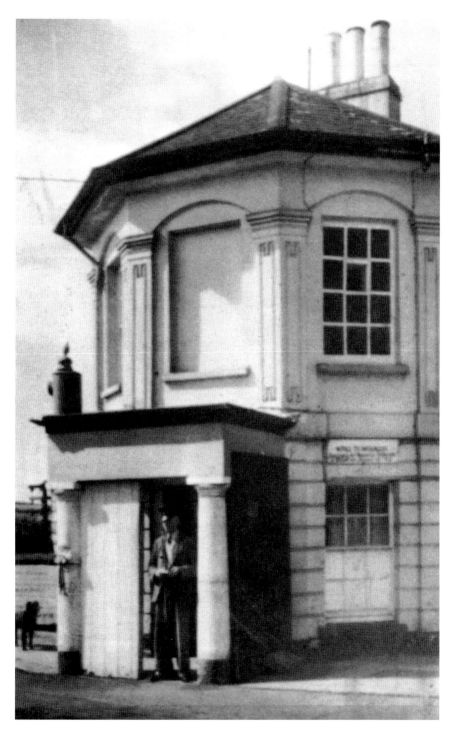

Edward Tucker standing outside the toll-house on the north (Teignmouth) end of the Shaldon Bridge, where he was gateman (see p. 32), 1943. The porch was later removed in the interests of traffic freedom.

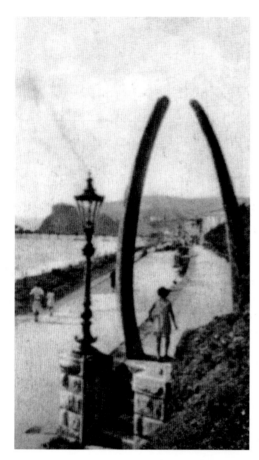

Whale jawbones were once a common enough sight in English seaside towns and Teignmouth was no exception. Those seen here around 1928 were erected by Mr Pike Ward, who was connected with the Newfoundland trade. They fell foul of the Council who, despite much local outcry, had them removed and thrown on the rubbish dump.

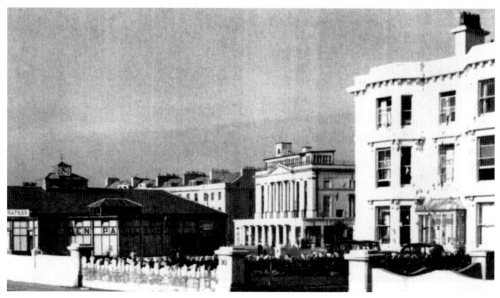

The Den Pavilion and Riviera Cinema (centre background) taken from the sea front, Teignmouth, *c. 1938*.

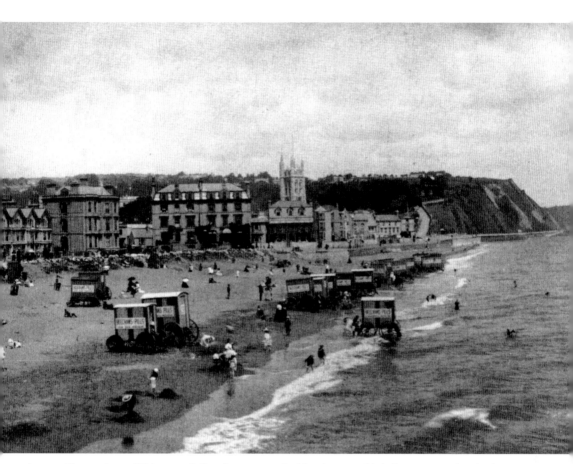

A magnificent view of Teignmouth Beach, *c.* 1905. Bathing huts enabled the more modest bathers, especially ladies, to change and be wheeled down the step straight into the water away from possible prying eyes. Here, as at Dawlish (see p. 130), the huts have been used as mobile billboards.

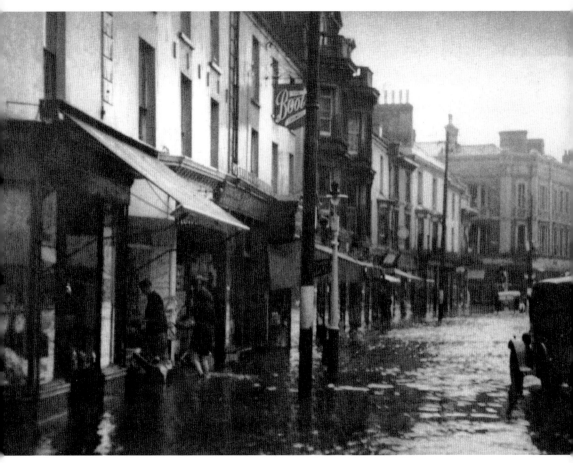

Although the pictures on this and the following three pages were taken following a flash flood in Teignmouth on 21 July 1939, they are also of great interest as they show parts of the town in the weeks immediately prior to the Second World War. This one shows the scene in Wellington Street.

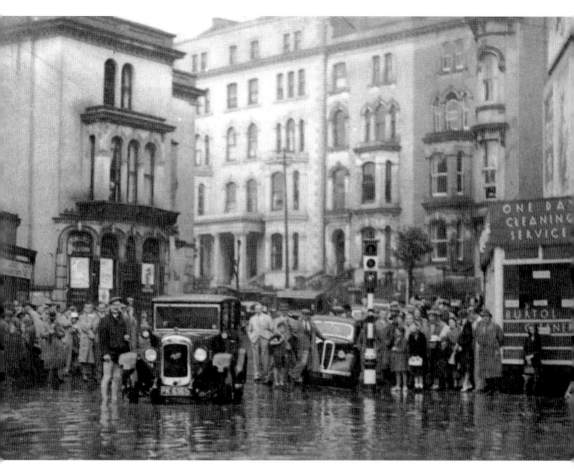

The same flood waters in Den Road. Obviously the Austin Seven driver is having second thoughts about venturing through – unlike the man in front of it 'showing a leg'.

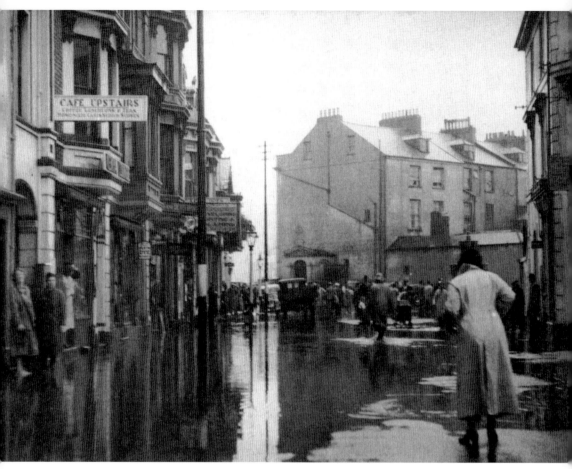

Little Triangle, Teignmouth. The lady on the centre right manages to give the impression she is waiting for a Sir Walter Raleigh to arrive complete with cloak for her to step on over the road.

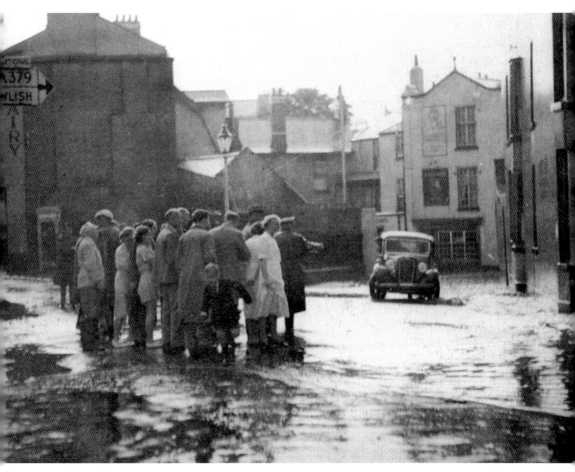

Regent Street, Teignmouth. Note the AA man (?), in front of a seemingly marooned gathering, giving instructions to the car driver coming 'upstream'.

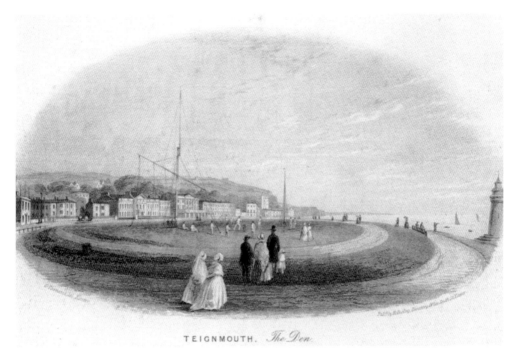

The Den, Teignmouth, *c.* 1860. Note the lighthouse.

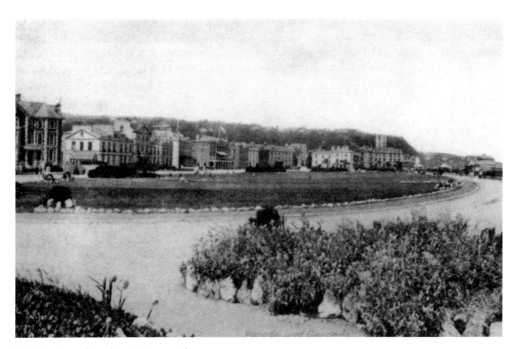

The Parade and gardens, Teignmouth, *c.* 1900.

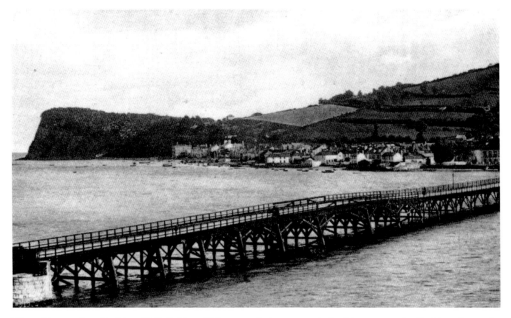

The old wooden Shaldon Toll Bridge, Teignmouth (see p. 32), looking towards Shaldon from the Newton Abbot road. This bridge was demolished and replaced in 1931 but is seen here probably just after the turn of the century.

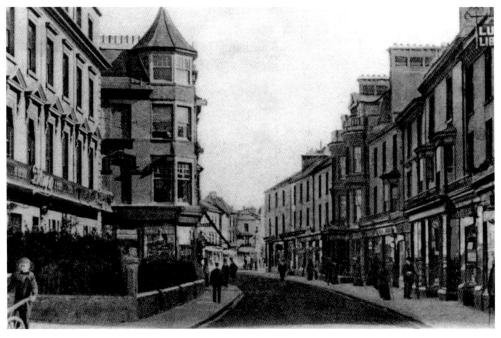

Wellington Street, Teignmouth, *c.* 1905. On the extreme left can be seen a boy pushing a three-wheeled delivery 'barra' (see p. 90).

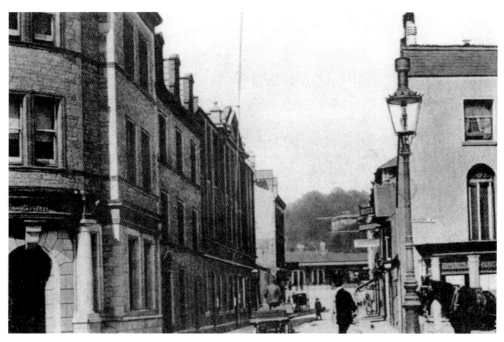

Looking into Station Road, Teignmouth, from Regent Street, *c.* 1904. The railway station is at the far end. Both the laundry and the police station, down the road on the left, have now gone (see below).

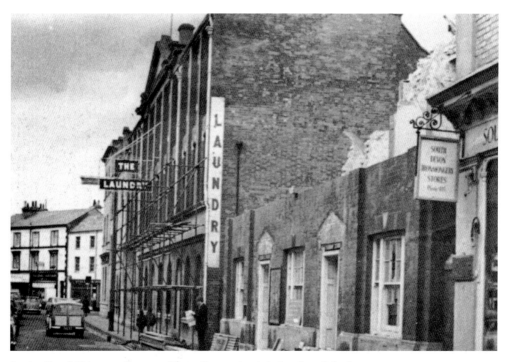

Station Road, Teignmouth, 1970. The police station is being demolished.

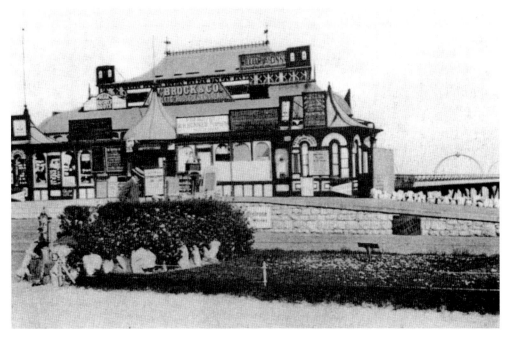

The pier, Teignmouth, *c.* 1900.

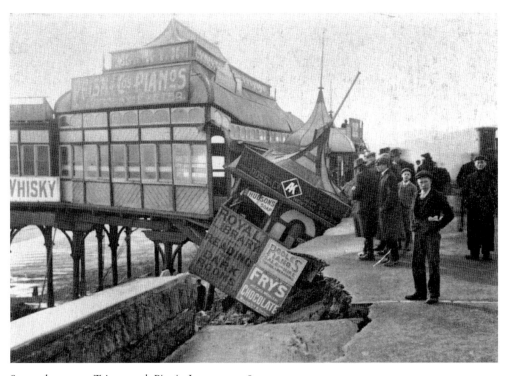

Storm damage at Teignmouth Pier in January 1908.

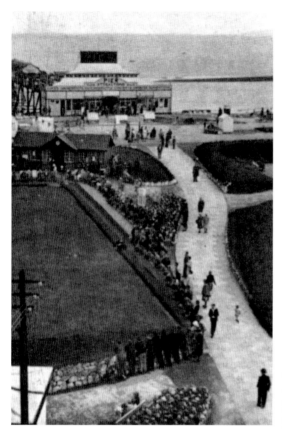

The pier and gardens, Teignmouth, in the 1930s. Note the more modest frontage, with less advertising than the pier in the previous pictures.

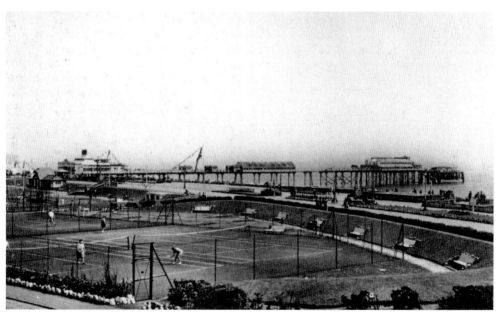

The tennis courts, Teignmouth, with the pier in the background, c. 1937.

Probably a carnival group, *c.* 1935. Included are Albert Turner, Sid Lane, Len Best, Bert Dodd, Frank Williams and Mr Knight.

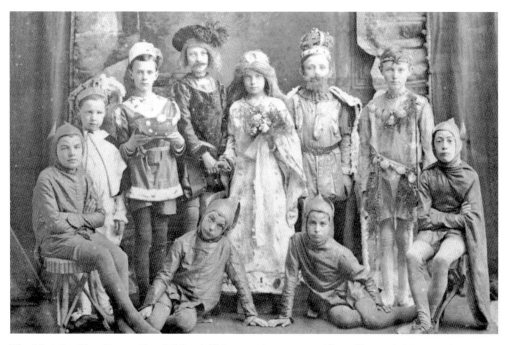

The Nativity Play, Exeter Road School, Teignmouth, *c.* 1900. Albert Turner (1886-1933), extreme right, was Teignmouth assistant postmaster.

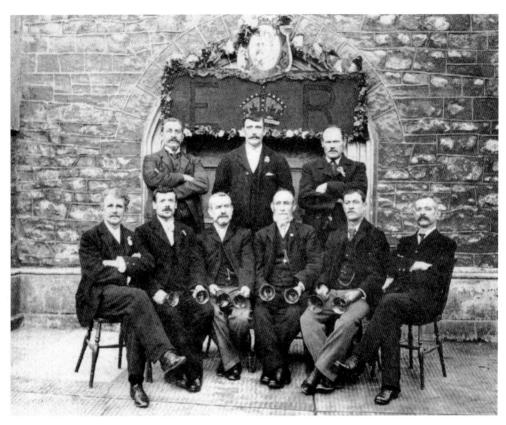

St James's Royal Ringers, West Teignmouth, who were engaged to ring at Dartmouth during a visit to that town of Edward VII and Queen Alexandra on 7 March 1902.

A superb study in late Victorian fashion on the north side of Teignmouth Pier, *c.* 1899. The gent on the right with the pipe is John Robert Thomas Whitear.

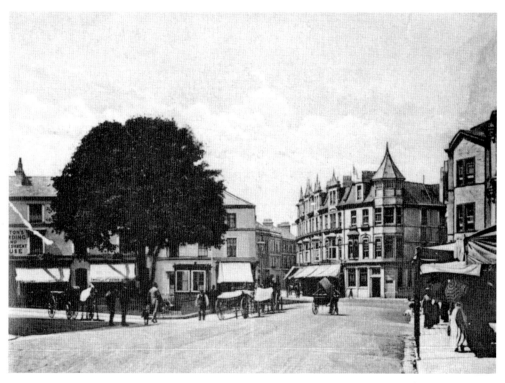

The Triangle, Teignmouth, *c.* 1900. Although the background, apart from the shop fronts, has changed very little, the handsome railings and tree have long since disappeared.

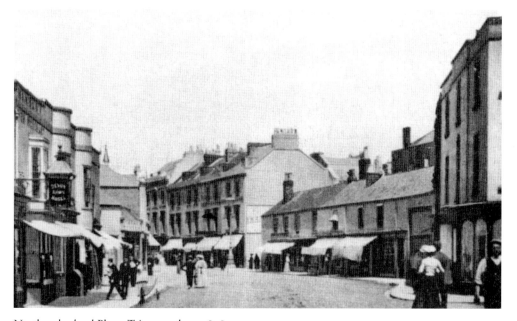

Northumberland Place, Teignmouth, *c.* 1898.

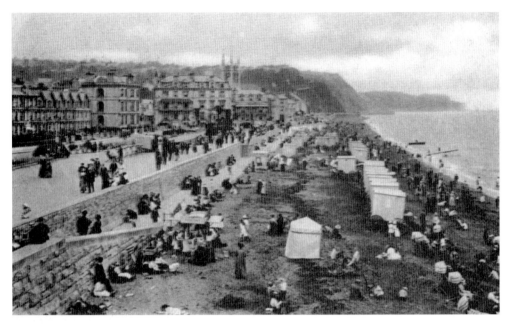

The beach, Teignmouth, *c*. 1920. This card was sold by A.E. Taylor, who ran a stationery and tobacconist shop at No. 22 Bitton Street.

Parson Street, Teignmouth, *c*. 1943. Much of the street has been demolished.

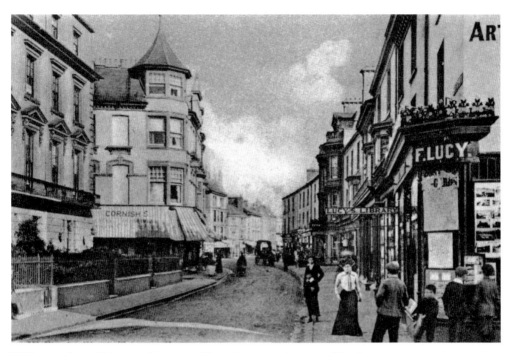

Wellington Street, Teignmouth, *c.* 1904. Note the untarred streets of the time.

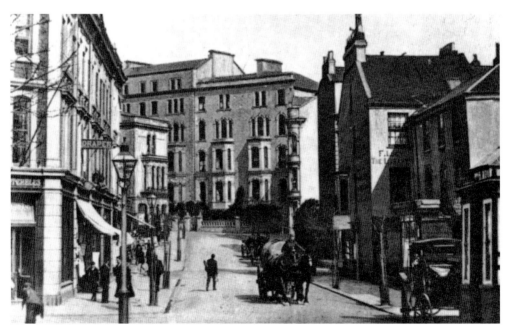

Den Road, Teignmouth, *c.* 1906. F. Lucy's library, which can be seen in the picture above, seems to have moved.

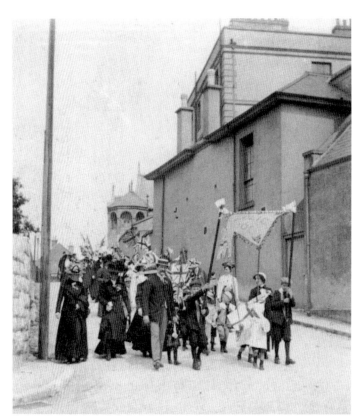

The Roman Catholic School parade for the coronation of George V in 1911. F. Finch and W. White are carrying the banner.

Artillery on manoeuvres on Haldan Moor, near Teignmouth, in the 1930s.

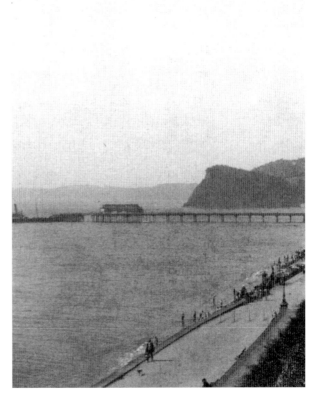

Cliff Walk, Teignmouth, *c.* 1908, looking towards the pier and the distant Torbay cliffs.

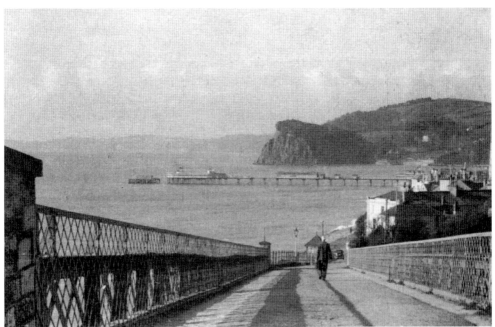

Further up Cliff Walk, looking over the railway bridge, in 1950.

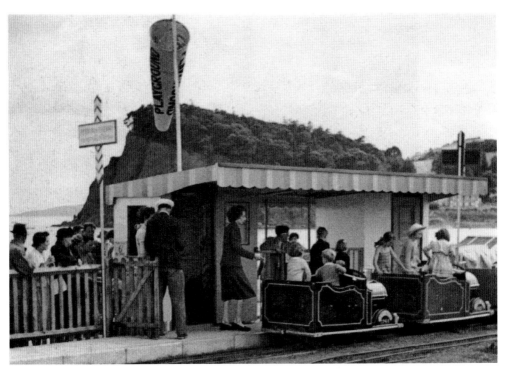

The Peter Pan Railway, Teignmouth, *c.* 1952. Once a popular part of the town's tourist attractions, the railway is no longer there today.

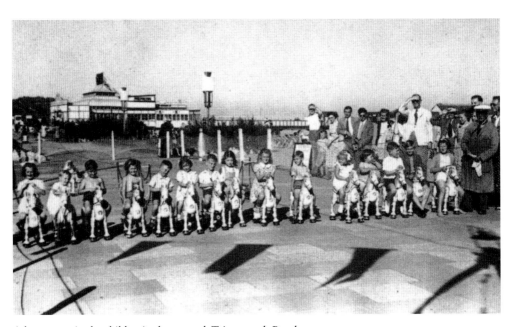

A horse race in the children's playground, Teignmouth Beach, *c.* 1950.

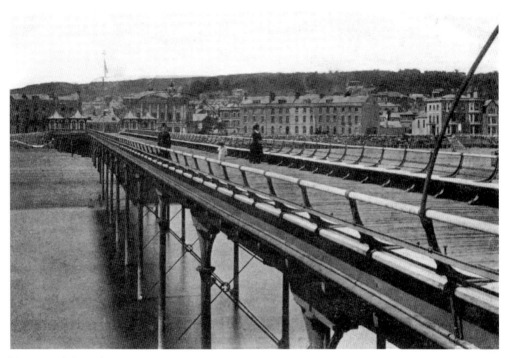

Teignmouth from the pier, *c.* 1890.

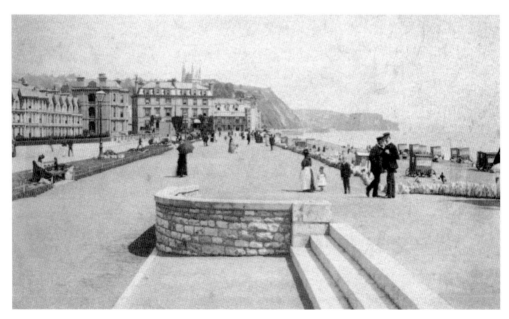

Teignmouth Parade, *c.* 1905. The Esplanade Hotel is facing in the background, while the Landrick is to the left.

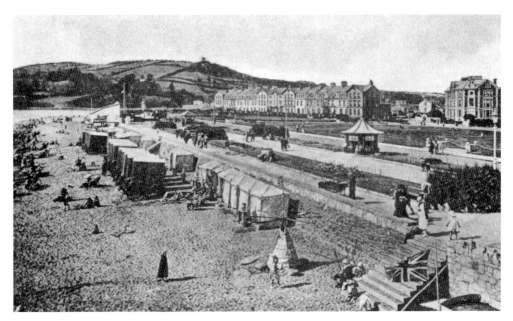

The beach and the Den, Teignmouth, *c.* 1919.

The west beach, Teignmouth, *c.* 1948, with the River Teign in the background.

three

The Villages

Ashcombe, seen here in 1910, is an idyllic village to the north-west of Dawlish and at the head of Dawlish Water, much of it once part of the Ashcombe Tower estate. It lies snug beneath Haldon Moor and is ringed by steep, wooded hills.

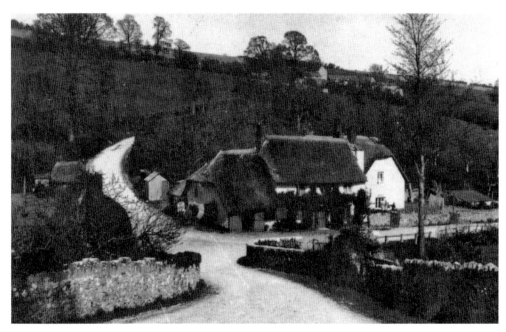

Ashcombe, 1910. This picture shows the post office and the village forge, which, at the time, was in the hands of the Coysh family, who had handed the business down from father to son since the reign of Elizabeth I. In the mid-1800s William Coysh was well known in the area for the quality of the cider he made and sold. The last members of the family, two brothers, died in the 1950s a few years before the forge was demolished after severe gales had damaged it beyond repair.

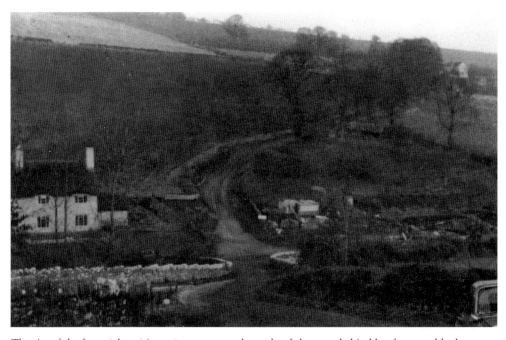

The site of the forge (above) in 1960; now even the orchard that was behind has been grubbed out.

Ashcombe School, *c.* 1910. It was closed in 1940 when the village children went to school in Dawlish but the building still stands as a private house. The last teacher in Ashcombe was Mrs Matta.

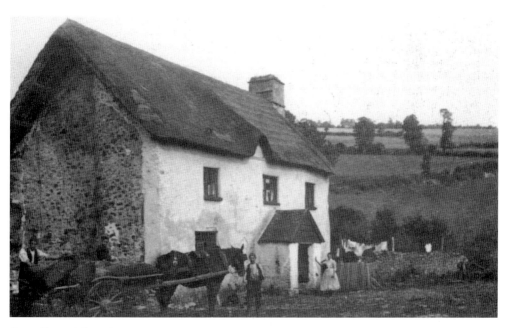

Court Farm, Ashcombe, 1905.

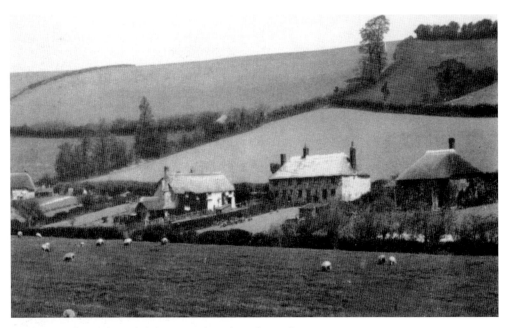

Cottages just beyond Dawlish Water on the Ashcombe road.

Holcombe, 1908. The village was given by Edward the Confessor to his chaplain, Leofric, who, when Bishop of Crediton, is said to have built cottages in the village. This picture, taken at the bottom of the hill near Smugglers' Lane, shows the now busy Teignmouth-Dawlish road, looking towards Dawlish.

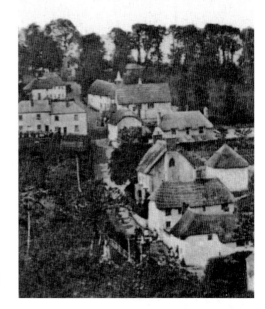

Holcombe, *c.* 1880. The tiny village has just the one street which, delightfully edged with thatch and cob, descends the steep hillside below the Castle Inn and then clambers up the opposite hill towards Teignmouth.

Holcombe post office. *c.* 1935. Now a private house.

Smugglers' Lane, Holcombe, c. 1912. Holcombe, like much of Devon's southern coast, was well connected with the smuggling trade and this lane was an ideal way up out of the lonely cove below; just along the coast road, of course, is the Smugglers' Inn.

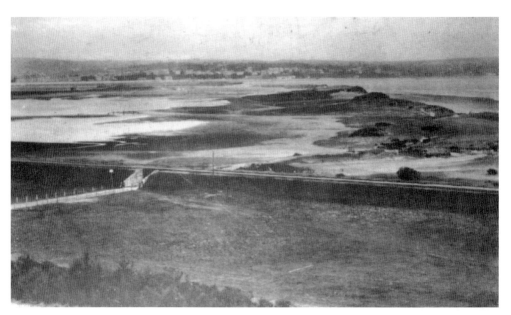

Dawlish Warren, c. 1875. It is almost impossible to link this picture with the Dawlish Warren of today; the main Paddington-Penzance line is there, but no golf-course, railway station, post office, bungalows nor holiday camps. By 1902 it was an 'exclusive' hamlet, whose residents were said to have thought the place spoilt by the opening of the golf-course; what they thought of the trippers who paid the sixpenny fare from Exeter after the railway halt was built in 1905, and who came to swim and picnic, is not known.

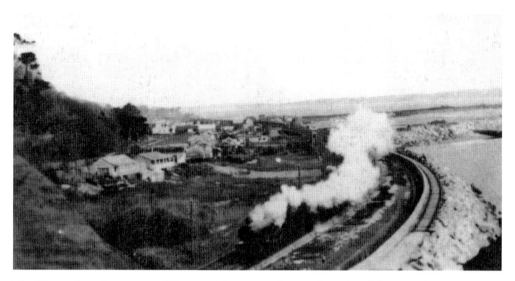

The Warren from Langstone Cliff, 1930. The railway line to the right of the main line was used to transport rocks for the protection of the sea-wall. The bungalows on the left have disappeared, the ground reverting to nature in the shape of self-sown lupins.

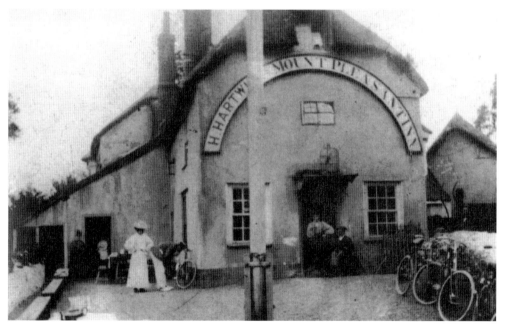

Dawlish Warren, c. 1900. The Mount Pleasant Inn was a popular stopping place, especially for cyclists – if only to pump up a tyre like the man on the left. In a later postcard (1914) the proprietor's name has changed from H. Hartwell to Hammett and the small building to the right has sported a sign offering 'Good stabling. Accommodation and motors and cycles.'

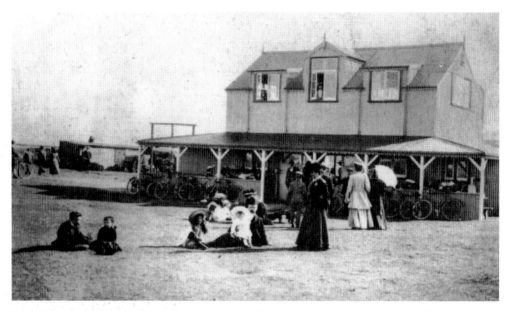

The Warren Restaurant, Dawlish Warren, *c.* 1910. The restaurant has since been demolished, replaced by a newer building and demolished again. It is once more interesting to note the number of cyclists who visited the Warren and, unlike today, were able to leave their cycles unlocked, secure in the knowledge that they would be there when they returned.

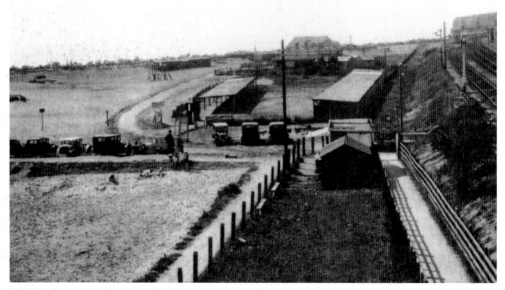

Dawlish Warren, July 1932. The entrance to Warren Beach. A few cars have begun to appear but it is still far removed from today's crowded summers.

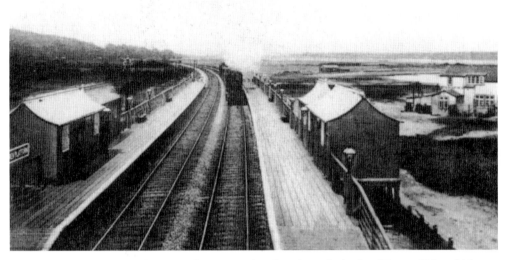

Dawlish Warren, *c.* 1910. The 'Cornish Express' thunders through the first Warren Halt, which was opened in 1905 but replaced by a station seven years later.

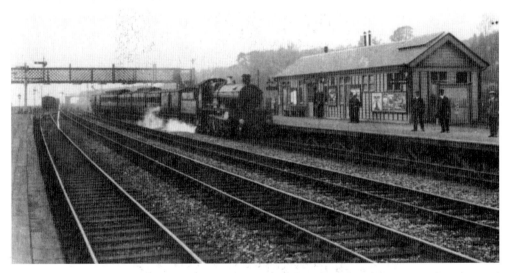

Dawlish Warren, 1914. The second station at the Warren was promoted to an actual station and opened on 23 September 1912, when the first train to stop there was the 7.10 a.m. out of Exeter St Davids. To mark the occasion the Union Flag was raised and fog detonators placed on the line. The first ticket was bought by Mr J.J. Nicholls of Eastdon Farm. The train seen here about to leave for Exeter is headed by a 4-6-0 'Saint' class locomotive, which is pulling three six-wheel coaches, the fourth (rear) van is an eight-compartment non-corridor bogie coach.

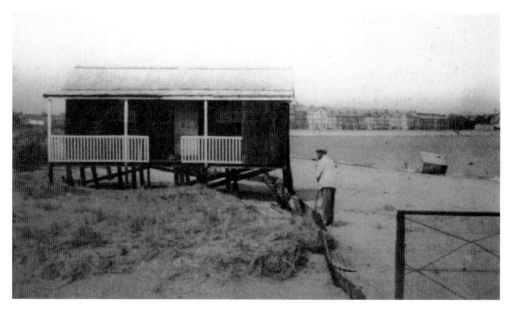

Dawlish Warren, *c.* 1938. Between 1900 and 1930 many wooden bungalows were built at the Warren and on Warren Point, the latter being cut off at high tides. Most were swept away by rough seas just before and during the Second World War, although one still remained as late as 1964. In this picture the concrete cesspit of one vanished building can be seen at the water's edge. Exmouth front, across the mouth of the river, is in the background.

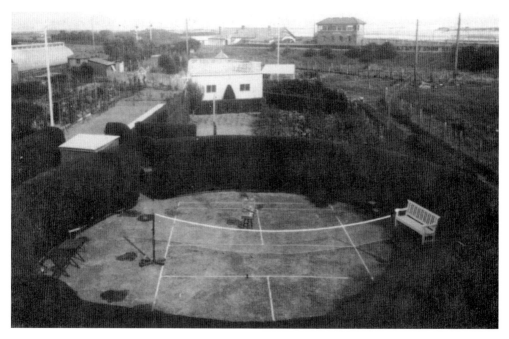

Dawlish Warren, *c.* 1935. An outdoor badminton court just north of Dawlish Warren station.

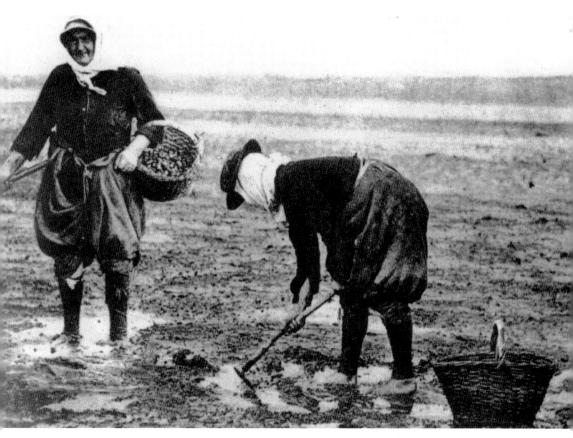

Cockwood cockle rakers, *c.* 1910. Cockle raking was a local industry run by the women of the village and is still carried out today, albeit in a small, amateur way. In the early days the women had a special dress with which, according to *The Homeland's Handbook Guide to Dawlish*, 'there was an opportunity for the advocates of Rational dress to study that form of costume on its native heath or, rather, mud. Long before Mrs Bloomer invented her costume, the cockle-scrapers of Starcross adopted what they call rational dress, a term of which to this day they are probably ignorant. But, with her old coat over her shoulders and her scanty skirts pulled lip and tucked into, well let's call them Rationals, you all know what I mean, and an old hat tied under the chin with a broad scarf or ribbon, the old cockle-scraper of Starcross plies her rake.'

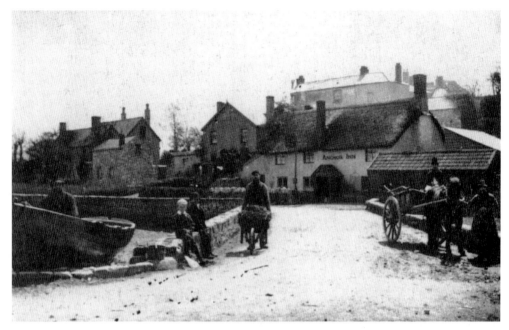

The Anchor Inn, Cockwood, c. 1880.

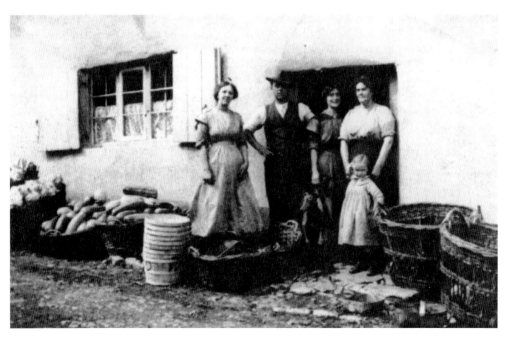

The Small family, Cockwood, c. 1916. Seen here outside their cottage, the Smalls were well known locally as market gardeners; some of their produce can be seen in the baskets.

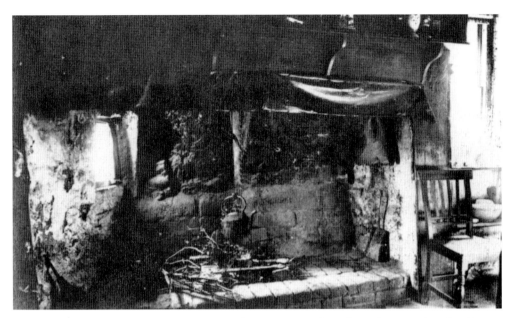

An old open fireplace, of a type seldom seen today, at Westwood, Cockwood, 1906. Note the chimney for such a fireplace at the side of the house in the picture below.

Cockwood village, 1906.

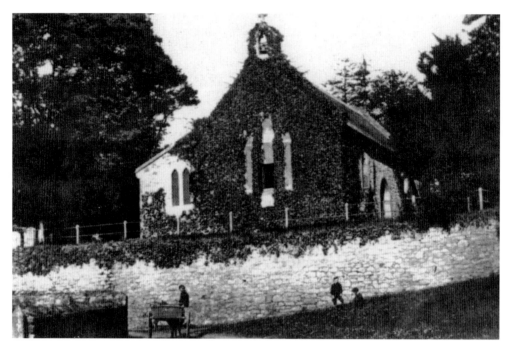

Cockwood, before 1875. The church of St Mary had fallen into disrepair by the end of the eighteenth century and was restored by the Earl of Devon in 1839. In February 1864 a district chapelry was assigned to the church by order of the Queen in Council and the Revd J. Lightfoot, who had been minister there for many years, became the first incumbent. This view shows the church without the porch, which was added in 1875.

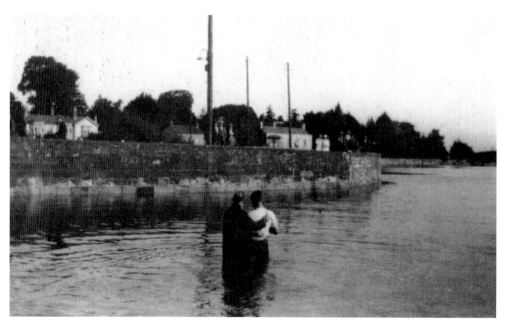

A baptism at Cockwood Sod, c. 1930.

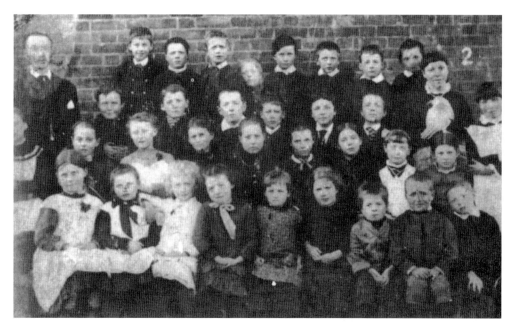

Cockwood School, *c.* 1900.

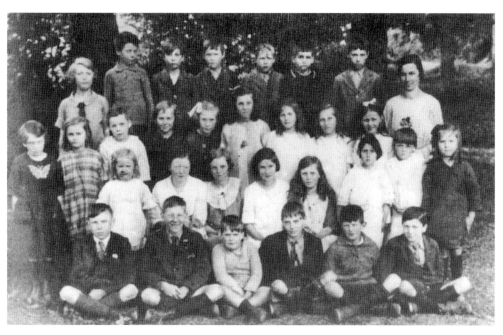

Ashcombe School, 1927.

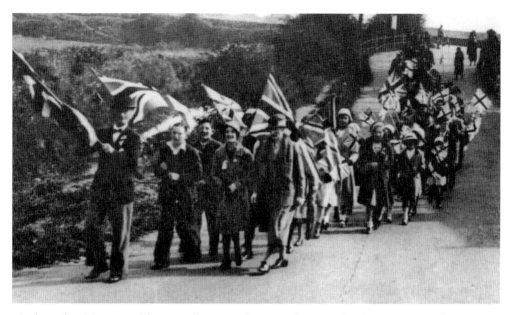

Cockwood, 6 May 1937. The tiny village staged its own festivities for the coronation of George VI, including the opening procession seen here.

William Jeffery, who lived to be 100 years old, was born at Chagford on 7 August 1866, and moved to Langdon Barton Farm, Ashcombe, in 1885. When he retired in 1920 he continued to live in the village but in 1952 he moved to live with his nephew, Bill Hendy, in Five Lanes.

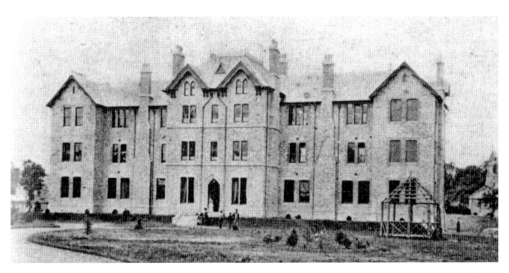

Starcross Institution shortly after it was opened on 16 June 1877. The Institution began in 1864 in a house leased from the Earl of Devon at £6 per annum and gave outstanding service in the field of mental illness until its closure in 1986. In 1946, shortly after patients came under the control of the National Health Service, the 'Institution' was dropped from the title. Today the site has been the scene of much development.

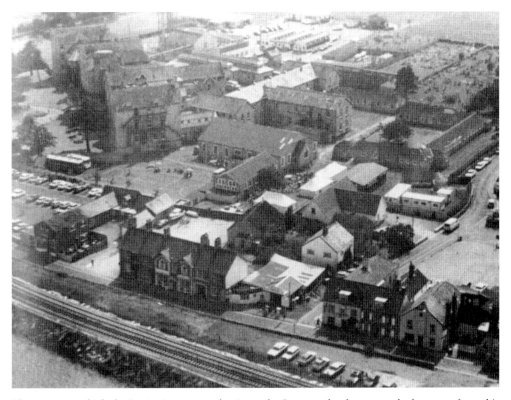

The extent to which the Institution was to dominate the Starcross landscape can be best seen from this aerial picture taken in the 1950s.

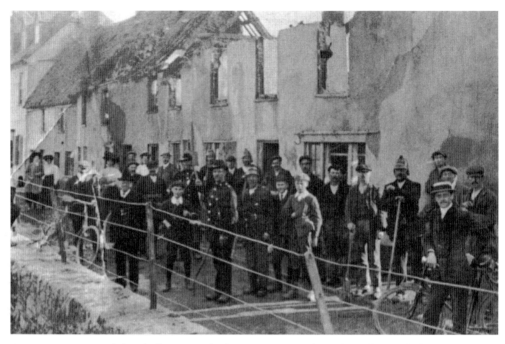

An attractive row of thatched cottages looking out across the railway line and the River Exe in Dawlish Road, Starcross, was destroyed by fire on 8 May 1909.

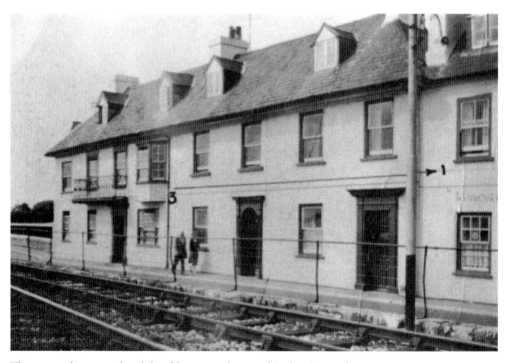

These smart houses replaced the old cottages destroyed in the picture above.

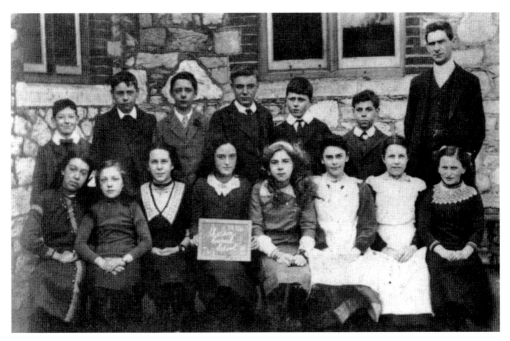

Shaldon School, 1914. Back row, left to right: Cyril Extence, ? Tothill, -?-, Richard Slater, Frank Trickey, Gerald Slater, Herbert Graham Jackman (headmaster). Front row: ? Solway, -?-, ? Passmore, ? Johnson, Mellie Prideaux, Gladys Rice, Nina Finch, -?-.

Shaldon, c. 1920. The Congregational church on the right is now the school hall, while Clifford House, behind it and across Bridge Road, was once the Clifford Arms Inn.

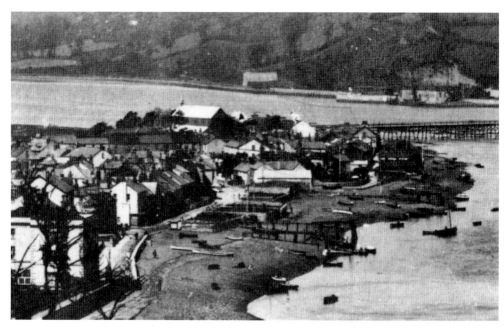

Shaldon, taken from the top of The Ness in 1895. The old wooden bridge was replaced in 1931. The large building seen at the Shaldon end of the bridge was a temporary corrugated iron building, used for some church functions while St Peter's was being built.

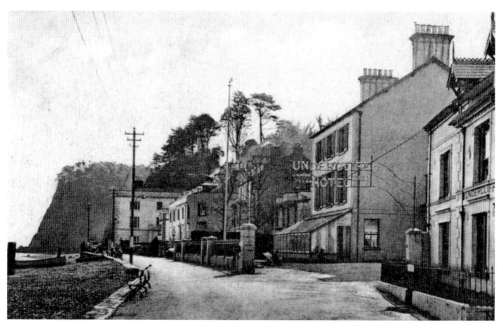

Marine Parade, Shaldon, 1935. The Undercliff Hotel, now demolished and the site used for flats, was bought by the vicar in the 1890s and occupied by him until he died in 1922. The vicarage provided by the Church was let during that man's lifetime.

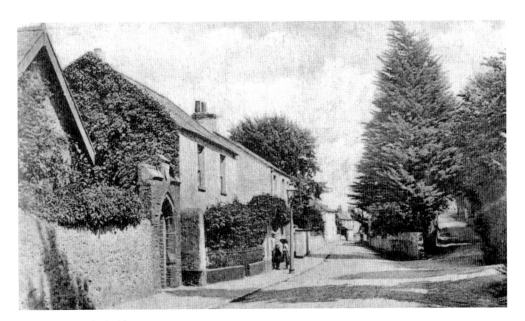

Ringmore Road, Shaldon, *c.* 1905.

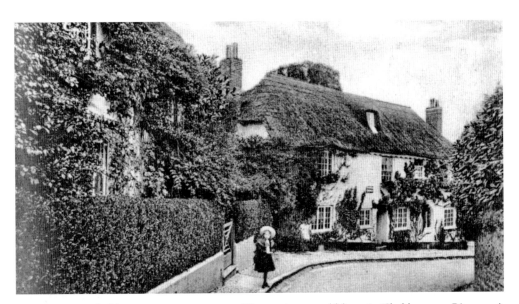

Ringmore near Shaldon, *c.* 1906, or, as many Ringmorians would have it, 'Shaldon near Ringmore'. Ringmore was all of the parish before Domesday. Shaldon, although it is now larger, was not recorded before 1600.

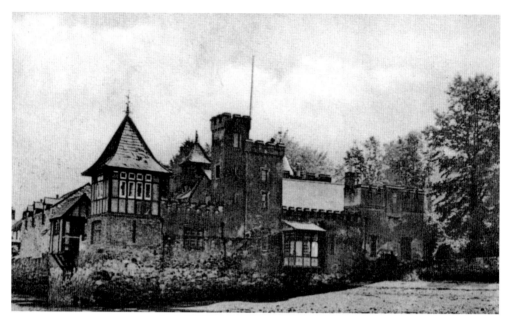

Ringmore Tower, Shaldon, *c.* 1920, built around 1890 more or less as a folly. The builder, Mr Collins, lived there until he died around 1925. The building is now converted into flats, which command outstanding views of the Teign estuary.

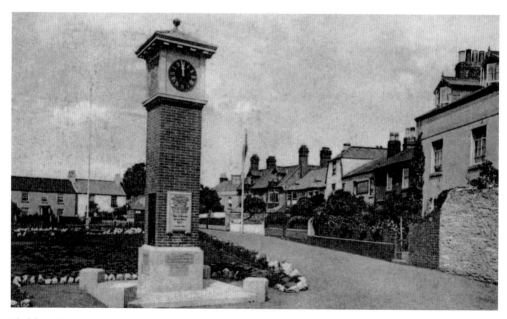

Shaldon War Memorial, *c.* 1930.

four

At Work ...

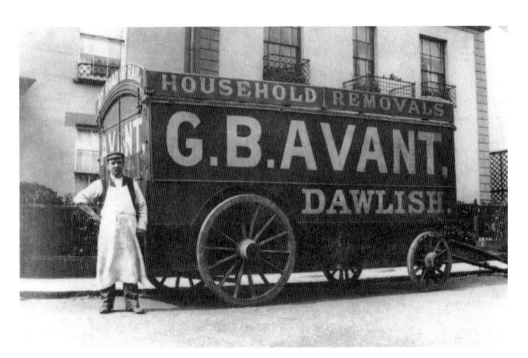

Barton Terrace, Dawlish, *c.* 1912. After the horse had pulled Messrs G.B. Avant's removal van to the scene of the move, it was taken back to the firm's stables until required to pull the full van away. For long-distance moves, the furniture only went as far as Dawlish station, of course.

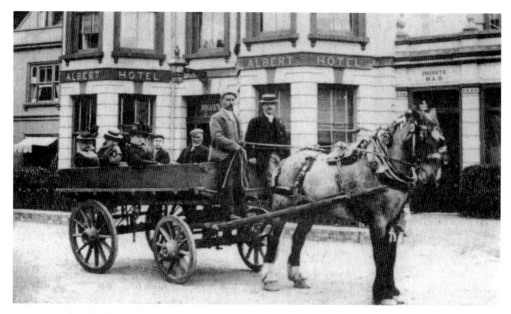

Messrs Bartlett, hauliers, Dawlish, *c.* 1900. The firm later moved to Teignmouth. Seen here outside the Albert Hotel (later the Grand Hotel), one of Bartlett's wagons has been converted for passengers and, in view of their Sunday-best look, hopefully cleaned at the same time.

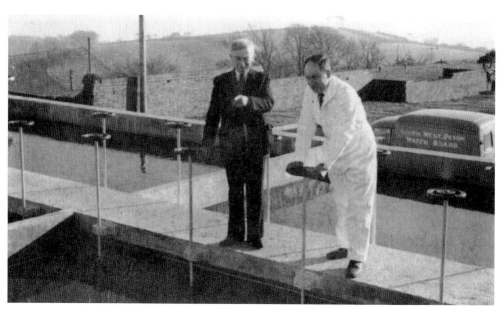

Burrows Reservoir, Dawlish, 1965. Built in 1883 to hold five hundred thousand gallons in two open tanks, and used by boys as a swimming pool despite the erection of walls topped with broken glass, storage capacity was later increased to one million gallons. In 1963, the control of the town's water supply passed from the UDC to the South-West Devon Water Board. Today it is part of the large (some would say too large) South-West Water Authority. George Casely was supervisor there for many years and is seen here (left) with his son, Raymond, who succeeded him.

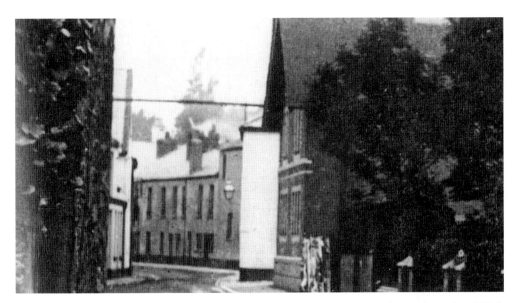

R.B. Ferris's Brewery, High Street, Dawlish, 1908. The brewery was situated on either side of High Street and the red-brick buildings are still there today; those on the right are now the shop and premises of Crocker and Williams, the local building firm. The brewery owned an off-licence shop on The Strand in front of the Hole in the Wall public house in Lawn Hill. The business was bought in 1825 by a Mr Brock of Botchell Farm but, due to inter-marrying of the Brock and Ferris families, it soon became known as the Ferris Brewery and supplied ale to twenty-four public houses in the Dawlish, Teignmouth and Exeter areas. In 1926, the business was bought by the Heavitree Brewery at Exeter and closed.

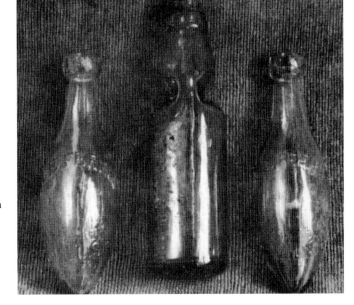

These bottles, once containing the produce of the Dawlish brewery, were commonplace in the town at one time. The one in the middle is an old-style lemonade bottle, which had a glass marble in the top. The others, being pointed at both ends, could not be stood up.

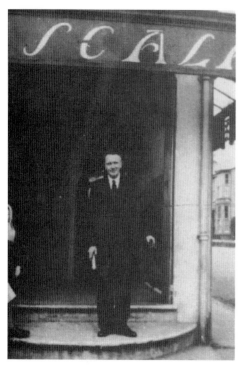

The Scala Cinema, Dawlish, c. 1938. The manager, Arthur 'Charlie' Payne, who is seen here in the entrance of the cinema, had been the part-time projectionist at the old Palace Cinema and became projectionist and manager when the cinema moved to Winton House in Lawn Terrace and changed its name to the Scala. The first film shown there was *Vaudeville*, and it was nothing during the 1930s to see queues stretching as far as the Perriam's (now the Information Centre). Sadly, and despite efforts to keep it open, dwindling support led to the Scala closing in September 1962. Today Barclays Bank and the library share the site.

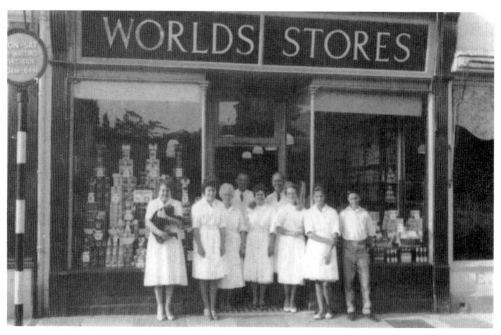

The staff of Worlds Stores, The Strand, Dawlish, c. 1964, which is now part of the Key Market store. Among those seen here are: Cyril Shorland (manager), Mrs Bolt and Miss Holman. Cyril Shorland, with his brother Stan, organized the local pantomimes for many years. Note that parking was allowed outside the store in those days.

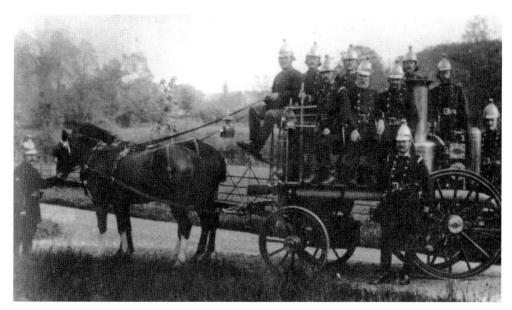

The *Sir Redvers Buller*, Dawlish's first official fire-engine, which was purchased along with all its equipment and uniforms for just under £300. The engine is seen here in 1900 on The Lawn shortly after its official christening by Mrs Charles Turner and a speech by Mr H.L. Friend, the chairman of the Council. Among the firemen present are First Officer Clarke and Second Officer Shapter. Prior to 1900 the only fire appliances in the town belonged to private insurance companies, who only dealt with fires at the properties of people who had policies with them. The first Dawlish motor appliance, also called *Sir Redvers Buller*, was bought in 1930 and served throughout the Second World War.

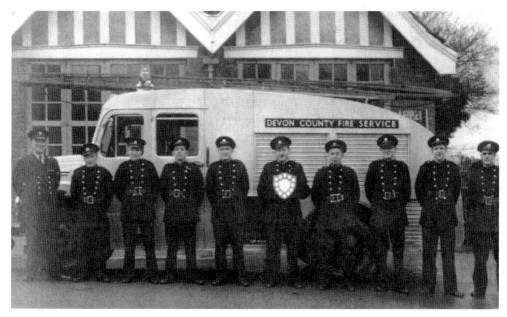

Dawlish Fire Brigade outside the fire station in 1965. Members include Fire Chief Stan Shorland and his son, Mr Martin and Mr Bryant.

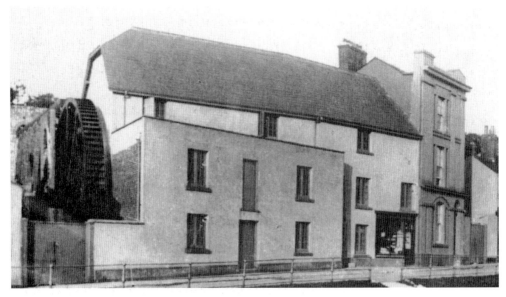

Torbay Mill, Brunswick Place, Dawlish, 1914. There was a mill on the spot at least as early as 1717 when it was known as The Strand Mill. It continued milling until 1959, when it became Brian Wills's furniture general store, and trades today as B.W. Wills. Of its machinery, only the giant wheel remains and even that is sadly rusting away. The water to drive the wheel came via a ¾ mile leat from Newhay, feeding Knowles Mill on its way, to reach the Torbay Mill through the top of the Manor Gardens and the back of Plantation Terrace.

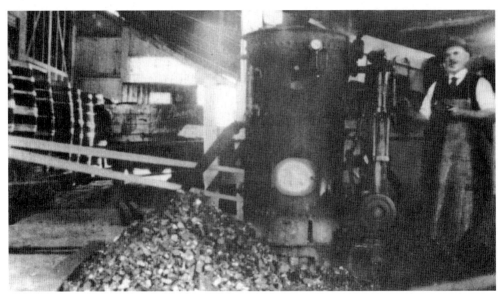

The Cyder Factory, Houndspool, Ashcombe Road, Dawlish, c. 1934. Cider-making began here in 1860 and, by the early 1900s, had grown into a considerable business marketing its products under a 'Dawlish Cyder' label. The business ceased in 1962 when the buildings were sold. Seen here is George Knowlesland, who doubled as a mill worker and lorry driver.

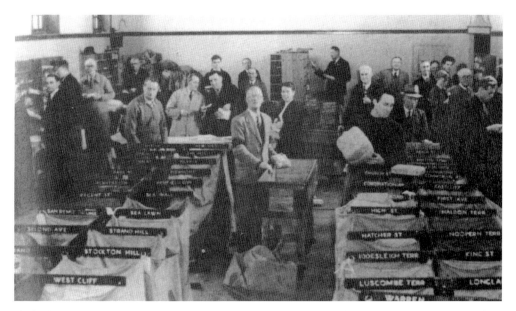

Shaftesbury Hall, Dawlish, December 1953. A temporary sorting-office was organized in the hall to cope with the Christmas mail until 1959 when the new post office in Brunswick Place was opened and able to cope.

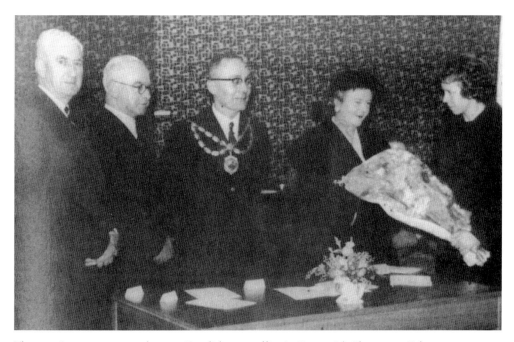

The opening ceremony at the new Dawlish post office in Brunswick Place on 9 February 1959 was performed by Mr R.C.L. Tomlinson, Dawlish UDC chairman. Left to right: Mr T.S. Wallace (Dawlish postmaster), Mr R. Philips (Exeter head postmaster), Mr Tomlinson and Mrs Tomlinson, who is receiving a bouquet from Miss Sylvia Dempsey.

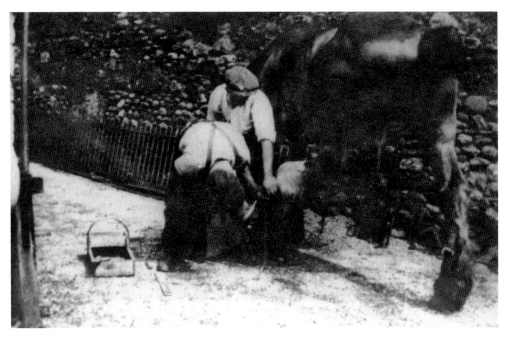

Shoeing at Penaligon's Forge, Old Town Street, Dawlish, *c.* 1932.

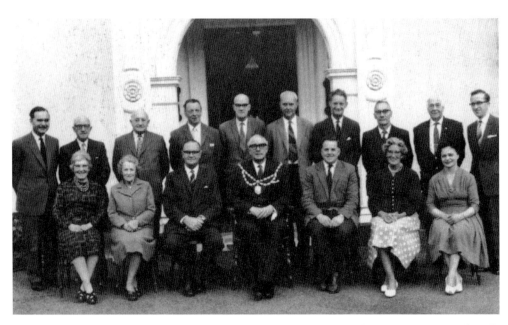

Working for others. Dawlish UDC at the Manor, 1963. Among members here are Mr Bill Kelly (chairman), Claude Smith, Mrs Blaiklock, Wilfred Adams and Tommy Tomlinson.

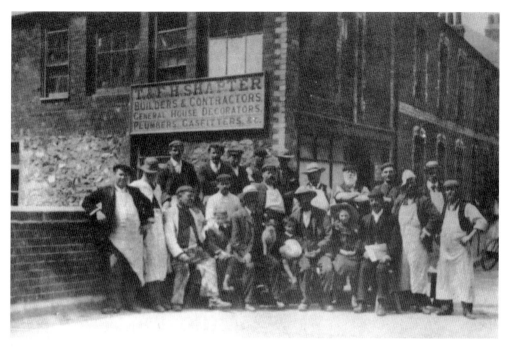

Members of the staff of the Dawlish building firm T. & F.H. Shapter seen outside the workshops and office at Alexandra Bridge, *c.* 1907.

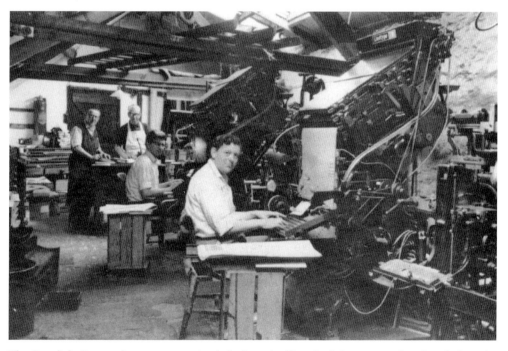

The *Dawlish Gazette* linotype room in their Strand offices in July 1966, a few days before the machinery was moved to larger premises in the old Scala Cinema.

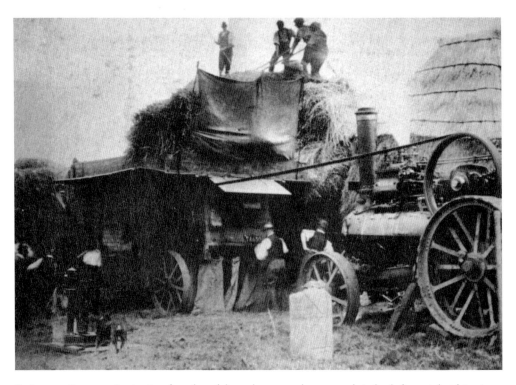

Patients at Starcross Institution found useful employment, therapy and, indeed, financial aid in many fields, especially, in a rural community, in agriculture. The top picture shows some at work threshing, while below a copse is being thinned, the felled trees to be used as posts.

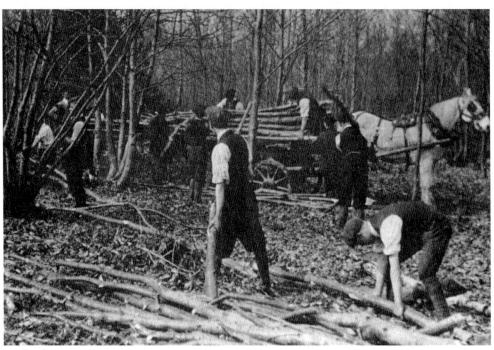

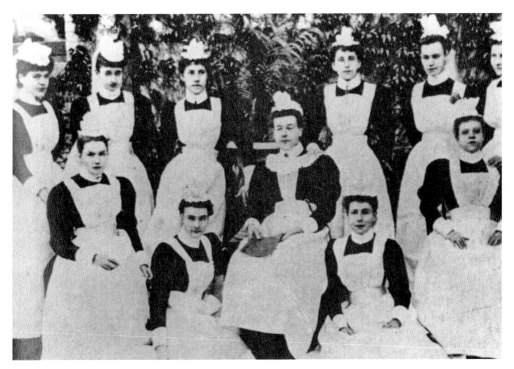

Nursing staff at Starcross Institution, *c.* 1925.

Cornish-Hobart's printing, stationery and toy shop on the corner of Wellington Street and Clampet Lane, Teignmouth, *c.* 1937. Occupied today by Sampson's the electricians, it was formerly Millett's. Mudge's, on the right, was a baker of some repute.

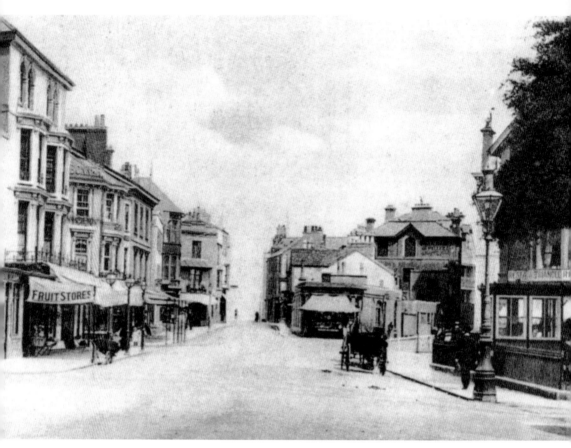

The Triangle, Teignmouth, c. 1901. Of particular interest in this picture is the three-wheeled 'barra' (barrow) parked outside the Fruit Stores on the left. A common sight in the town at one time, they did not vanish entirely until the 1950s. They were specially designed to navigate the narrow streets for which Teignmouth is so well known. If used to deliver across the toll-bridge to the Shaldon area, for which the toll used to be a penny a wheel, the delivery boys would take off the back two wheels and carry them over on the 'barra', thus only paying a penny toll. The boys did not get the tuppence that had been saved, however, as their employers only gave them a penny when they left the shop. On the right, immediately behind the gas lamp and in front of the Triangle Restaurant, is the cabby shelter.

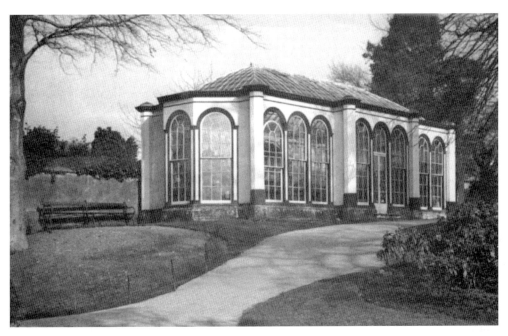

The Orangery, Bitton Park, Teignmouth, *c.* 1939. The Orangery, restored in the early 1980s, was built along with Bitton Park between 1812 and 1830. Today the park is the home of Teignmouth Town Council.

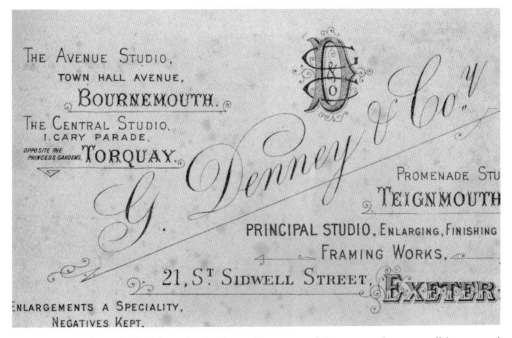

THE AVENUE STUDIO,
TOWN HALL AVENUE,
BOURNEMOUTH.

THE CENTRAL STUDIO,
1. CARY PARADE,
OPPOSITE THE
PRINCESS GARDENS. TORQUAY.

G. Denney & Co.

PROMENADE STU
TEIGNMOUTH

PRINCIPAL STUDIO. ENLARGING, FINISHING
FRAMING WORKS.
21, S.T SIDWELL STREET, EXETER.

ENLARGEMENTS A SPECIALITY,
NEGATIVES KEPT.

G. Denning & Co., who had branches in Exeter, Torquay, and Bournemouth, were well known and popular photographers in Teignmouth during the latter years of the nineteenth century. They traded from the Promenade Studios on the sea front.

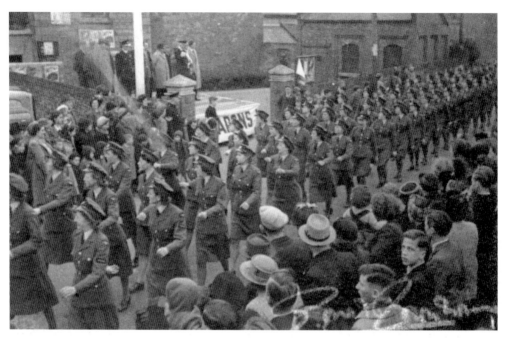

Working for Victory. 'Waafs', members of the Women's Auxiliary Air Force, on parade and giving a smart 'Eyes Right' during the War Weapons Week in Teignmouth in April 1943.

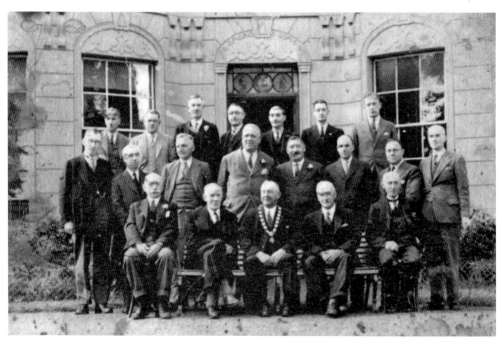

Working for others. Teignmouth Urban District Council, *c.* 1938. Mr A.J. Hocking (chairman) is front centre.

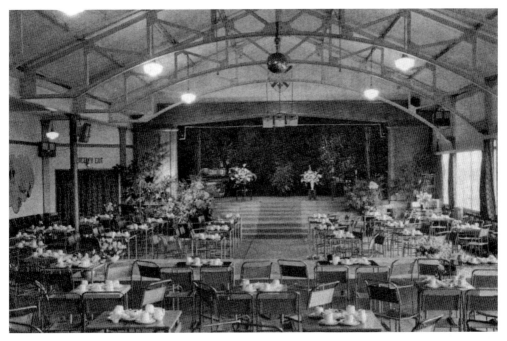

The interior of the Den Pavilion, Teignmouth, *c.* 1947. The building is still there, but is now the Carlton Theatre, of course.

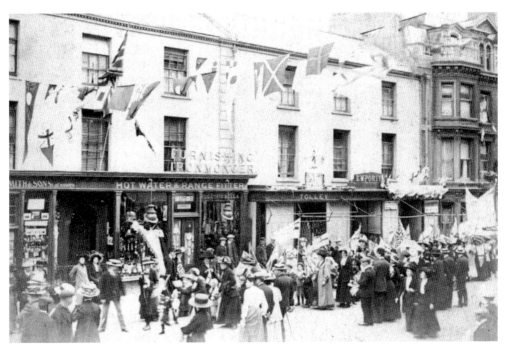

W.H. Smith & Sons, still Teignmouth's leading bookshop, and Tolley the ironmongers, now Boots, seem to have caught the mood of the moment during the celebrations for George V's coronation in 1911.

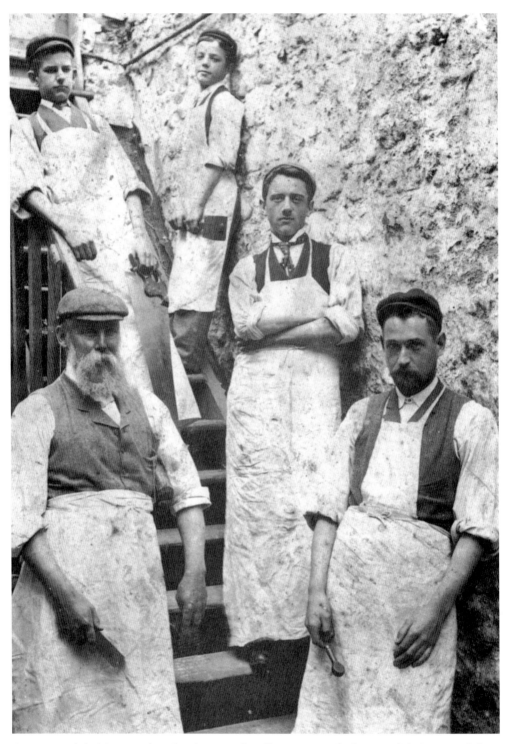

Carpenters of the Teignmouth undertakers Brook Bullen pose outside their Dawlish Street workshop, c. 1890.

five

... and Play

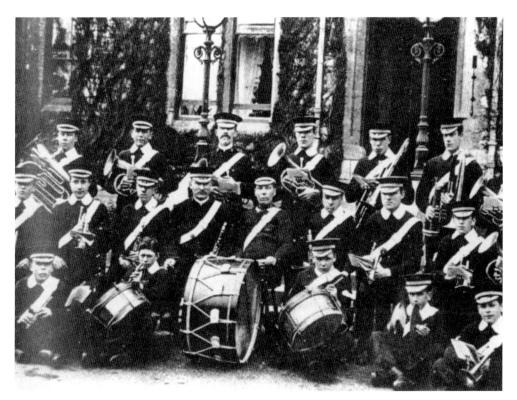

The Starcross Institute Band, seen here around 1923 and consisting of both staff and patients, was a great success and in demand at most local functions.

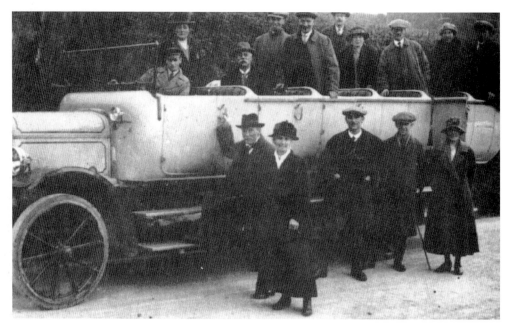

An outing to Bampton Fair in November 1920 in the first charabanc to be operated from Dawlish. It was owned by Gordon Shapter, who received a licence to run it on 7 April 1920. The vehicle had solid tyres and a separate door for each row of customers. By 24 April, Shapter was advertising in the *Dawlish Gazette* that his charabanc 'would run to Hay Tor on Sunday, weather permitting'. The fare was 6s.

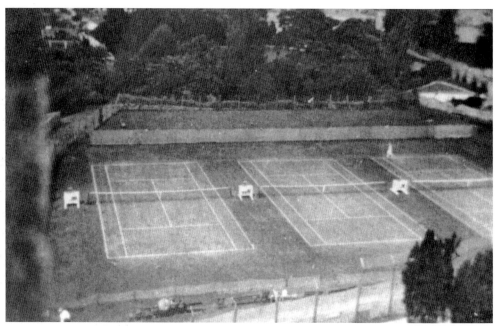

Newhay tennis courts, Dawlish, *c.* 1926, viewed from the church tower. Considered rather exclusive, the courts were not open to the general public. The site is now occupied by old people's flats.

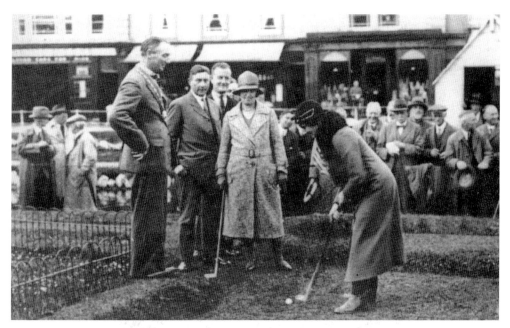

Mrs Fred Jenner opens the 1933 season at Dawlish putting-green. It had been Mrs Jenner, along with Mrs Tommy Shapter, who had made the first putts when the green was opened in 1930; then a match between the Council and the Bowling Club followed. Mr Jenner, chairman of Dawlish UDC, and Mr Holman are also present.

Mr Arthur Bearne presents Mr J. Chitty with a gold watch to mark his twenty-five years as professional to the Dawlish Warren Golf Club in 1925.

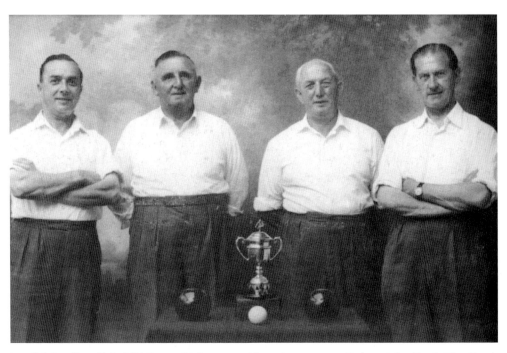

Dawlish Bowling Club, Mid-Devon Rinks competition winners, 1956. Left to right: Frank Way, Frank Hill, Fred Shelston, Charlie Crook.

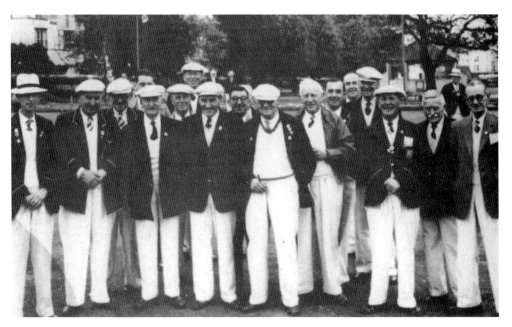

Dawlish bowling-green was opened on 11 May 1907, the pavilion following in 1924, and it has been an important part of the town's recreational attractions for both resident and visitor ever since. Here members pose during the green's jubilee year in 1957. Among those present are Cyril Briscoe, Frank Way, Hedley Way and Mr Tuck.

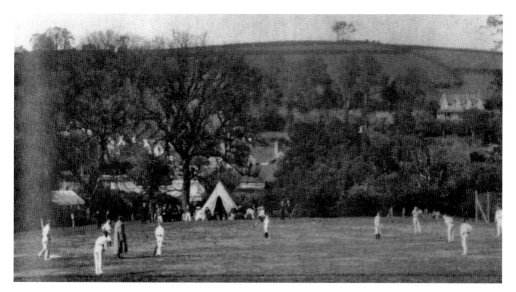

Cricket at Newhay, Dawlish, *c.* 1906. Dawlish Cricket Club, after a chequered existence in the nineteenth century, was reformed following a meeting at the Shaftesbury Hall on 29 May 1899. They played at Luscombe Castle for a short while, then, at different times, at Knight's Field (at Secmaton Farm), Reeves Hill, and Newhay and Copp's Field before moving to the new Marina playing fields in 1935. Stalwarts of the time, who are almost certainly playing here, included Major C.T.W. Church, Revd J.J. Turpin, Mr W.T. Opie and Mr V.W. Gay.

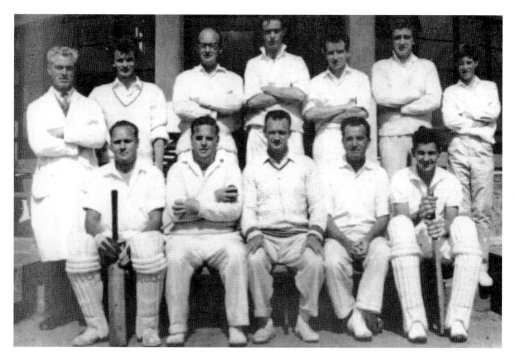

Dawlish Cricket Club, 1962. Members seen here include Michael Cockram, Jack Bradley, Derek Cole, Alan Hopkins, John Aggett and Claude Smith.

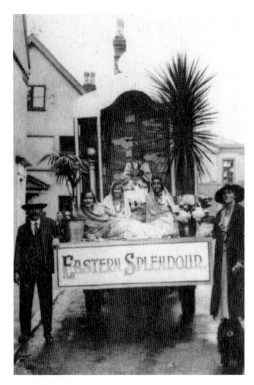

Bill and Anne Lambshead with their 'Eastern Splendour' tableau for Dawlish Carnival, *c.* 1934.

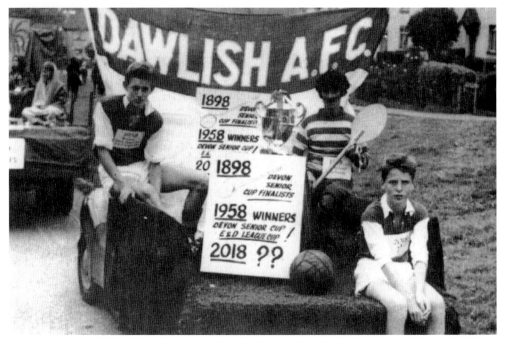

Dawlish Football Club's entry for the 1958 carnival proudly shows that it had just won the East Devon Senior Cup. At the time the club was one of the best amateur sides in the county and probably the best in the Premier Division of the Exeter & District League, in which it competed.

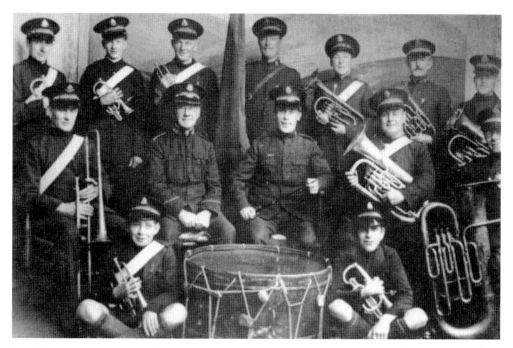

Dawlish Salvation Army Band, *c.* 1935. Mr Shelston is on the left in front.

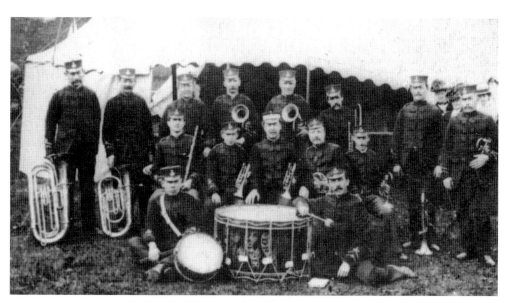

Dawlish Town Band at a fête at Luscombe Castle, 1902. Included are Arthur Moore (bandmaster), G. Marchant, E. Morrish, T. Shapter, H. Sage and W. Edmunds.

Four members of the Dawlish church choir who won the quartet competition at the Torquay Eisteddford, *c.* 1923. Left to right: Bill Lambshead (baritone), Alf Davey and Cyril Simkin (tenors) and, seated, Harold Foster (bass).

The first pantomime in Dawlish, *Babes in the Wood*, was staged in the Hut in 1934 and was so popular that audiences voted to make pantomime an annual entertainment. The 1937 production was *Aladdin* and the cast included, left to right, Son Williams, Stan Shorland, Jack Bradley and Reg Scagell.

Around 1928 a team of Dawlish boy scouts were winners of the Duke of Connaught Rifle Shooting Trophy. The competition was open to scouts from all over the world, and in the final Dawlish met and defeated a team from South Africa. Left to right: Tom Jennings, Jack Burgess, Lance Tapper, Ewart Crapp, John Mitchell, Tim Burch.

St Gregory's church bell-ringers, Dawlish, *c.* 1902. George Gay is second from the right, his son, Wilf, in front.

The Old Folk's Centre in the Manor Grounds was financed by the proceeds of Cyril and Stan Shorland's pantomime company. Voluntary labour came from members of Dawlish Toc H (seen here and including Bill Selley, Syd Thorp and Humphrey Craddick) and construction began in late 1954. The centre was opened in March 1956.

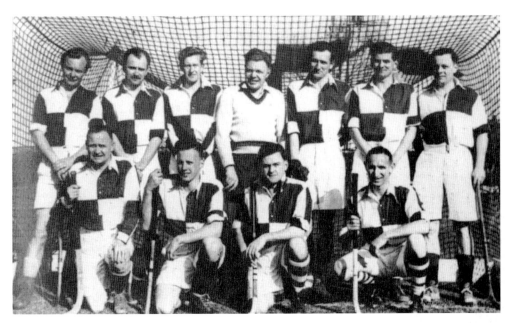

Dawlish men's hockey team, April 1955. Members here include Dr Peterkin, Alan Hopkins, Syd Vigers and Derek Cole.

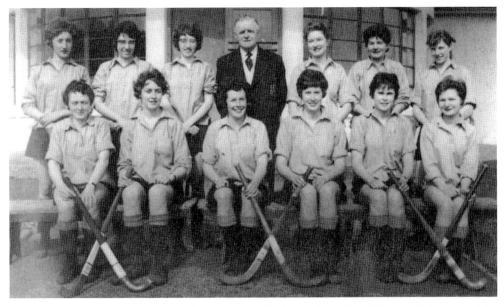

Dawlish ladies' hockey team, 1961. There were two hockey clubs in Dawlish around the turn of the century, the Elm Grove Club, which was 'open to ladies and gentlemen', and the Dawlish Hockey Club. Neither prospered, and a meeting was held in 1906 to revive the game, which then thrived until the Second World War intervened. The men's club was restarted by Messrs A. Hopkins, J. Bealey, D. Cole, B. Caunter and D.B. Peterkin; a ladies' club, originally formed in 1954 for both Dawlish and Teignmouth players, became Dawlish Ladies' Hockey Club. Members here include the two Miss Newtons and Miss Bolt.

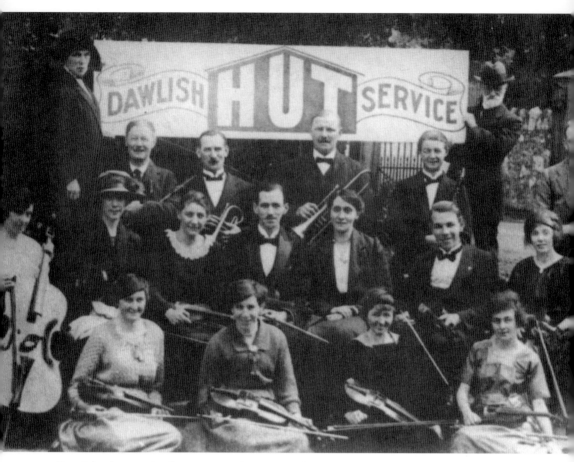

Dawlish Pleasant Sunday Hour Orchestra outside the Hut, *c.* 1938. The members include Jack Gibbings, Will Pike, Lilian and Dorothy Chapman and Jimmy King.

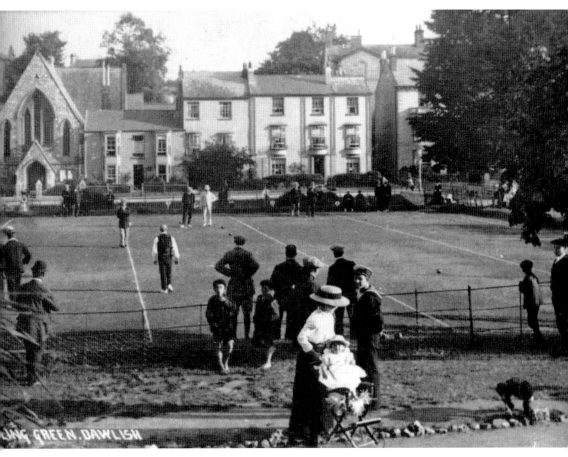

Dawlish bowling-green, c. 1913. Although the turf was nothing like the pristine playing surface of today, there had been bowling on The Lawn long before the bowling-green was opened on 11 May 1907 amid much opposition because 'the general public would rise in arms at an encroachment [on The Lawn] for a few.' And it was probably this that kept the membership fee down to 2s, 'otherwise it would keep many working men from joining.' The team's first captain was Fred Avant. The pavilion was built in 1924, but not before the club had had to guarantee £75. So popular had the game become that, on 11 May 1940, another green and pavilion was opened in the Marina playing fields (opened in 1935); this too was a subject of much controversy in the town, but a ladies' club was formed and from that grew today's thriving Marina Bowls Club. Both the Dawlish and Marina clubs are added attractions to Dawlish's summer visitors. This picture is of extra interest for the fine view it gives of the Wesleyan chapel in Brunswick Place.

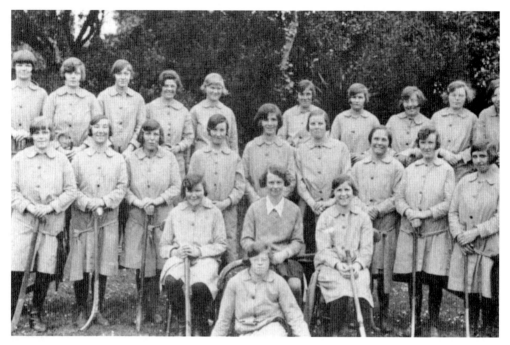

The girls' hockey teams from Langdon and Starcross Institutes find time to smile during a game in the 1930s.

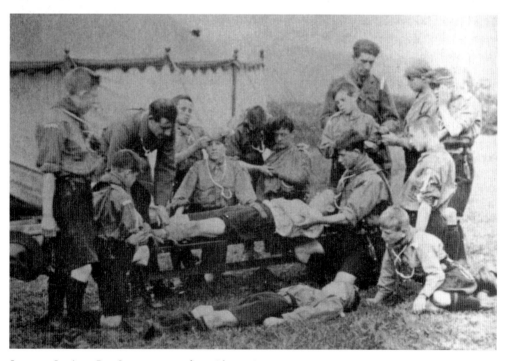

Starcross Institute Boy Scout troop at first-aid practice, c. 1928.

Shaldon Mothers' Union Silver Jubilee Year, 1954. Among those helping at a fête in the vicarage gardens are Mrs G. Tothill (centre) and Mrs Hilda Mole.

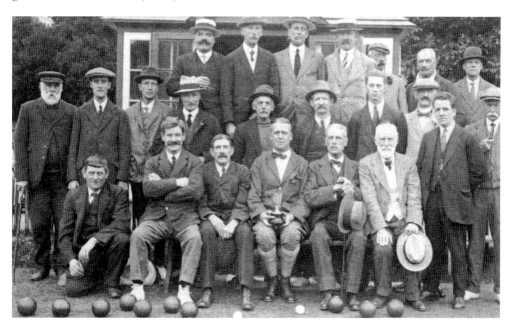

Shaldon Bowling Club was formed in 1913. Members seen here in 1920 after the pavilion had been built are, back row, left to right: Richard Evans, Henry Codner, Ned Palk, Albert Vanstone, William Follett, John Gilbert, Mr Evans. Second row: John Hore, Mr Stevens, Fred Gilbert (the Shaldon Toll Bridge keeper), Samuel Soden, Harry Easterbrook, Fred Stone, Percy Palk, Arthur Boyes, John Lewis, James Golden. Front row: Jack Hares, Charles Underhill, Tom Aplin, Edward Palk (a local butcher who was chairman of Teignmouth Council), Robert Bates, Fred Wheatley.

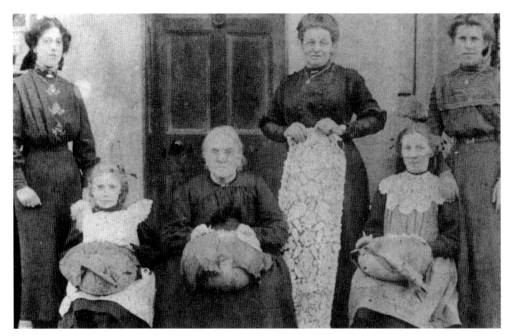

Shaldon Lace School. Standing, left to right: Mrs March, Mrs Withey, Elizabeth Passmore. Seated: Doris Richards, Mrs French, Dorothy Hosegood. As the lace held by Mrs Withey is part of that made for Queen Mary's coronation in 1911, the picture was taken either in that year or late 1910.

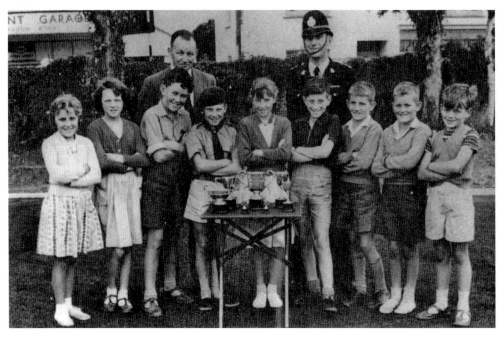

Cycling Proficiency Challenge Cup winners at Shaldon School, 1961. Left to right: Elaine Winsborrow, -?-, ? McCarthy, Robert Maythorpe (headmaster, behind), ? Peterson, -?-, Police Constable Vokes, ? Parker, Neil Winsborrow, Paul Winsborrow, Nigel Thomas.

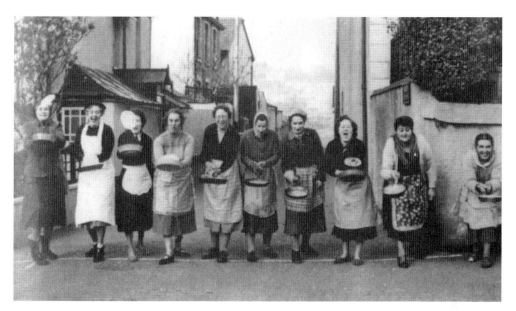

Shaldon Ladies Pancake Race, 1955. Lined up for the off on The Green are, left to right: Mrs Whitmore, Grace Peat, May Bangs, May O'Gorman, Mrs Gaskin, Mrs Clare, Mrs Bill Roberts, Mrs Corden, Mrs Stillman, Mrs Marsh.

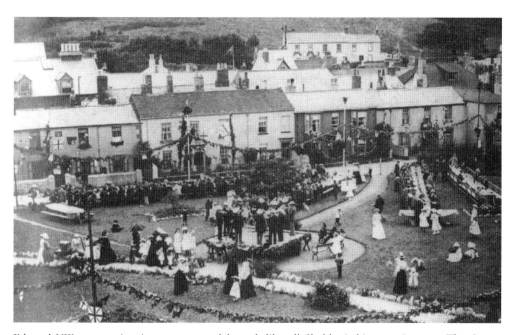

Edward VII's coronation in 1902 was celebrated, like all Shaldon's big occasions, on The Green. The children's tea-party is in progress on the right while the band plays on a specially constructed dais. Note the fields of the rope-walks in the background, now built on. Apart from there being no Homeyards, Broadlands or The Hamilton, and, of course, no bowling-green, the houses in this area are little changed today.

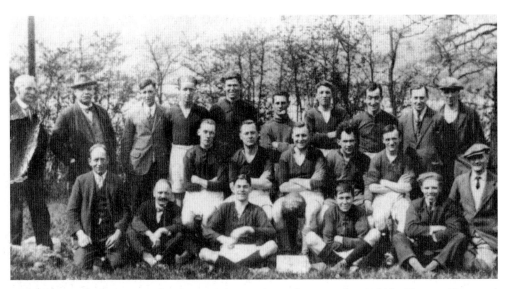

Shaldon Football Club, 1930. Back row, left to right: William Fowler Gribble, Thomas Townsend (landlord of the Crown Inn), Fred Delbridge, Ron Stonelake, Jim Bulley, Wally Bangs, Mr Peterson, Ken Dodd, Sam Stewart, Arthur Wakeham. Second row: Albert Lakeman, Tom Underhill, Harold Parker, Jack Back, Tom Tooley. Front row: Harry Ware, Tom Shepherd, Warwick Freeman, George Stoneman, Lewis Peterson, Sidney Hosegood.

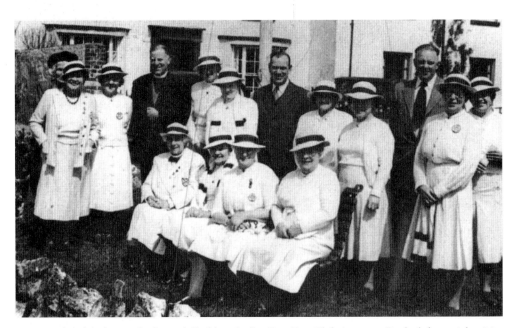

Opening day for the newly formed Shaldon Ladies Bowling Club in 1951. Back, left to right: Mrs Back, Mrs Moore, Mrs Pratt, Revd W.A.E. Westall (who left Shaldon and went on to become Bishop of Crediton), Mrs Wilkey, Mrs Bobbett, Mr Douglas Chapple, Mrs Merchant, Miss Jackson, Mr Jack Best, Mrs Kingwell, Mrs Little. Front: Mrs Golden, Mrs Tothill, Mrs Pearce, Mrs Harvey.

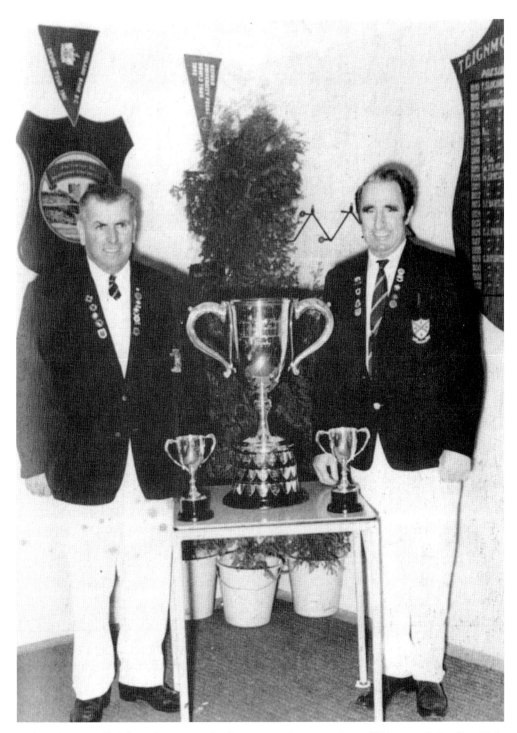

Arthur Skinner-Hill (left) and Harry Rodwell, two prominent members of Teignmouth Bowling Club, seen in the early 1950s when they were County Pairs winners.

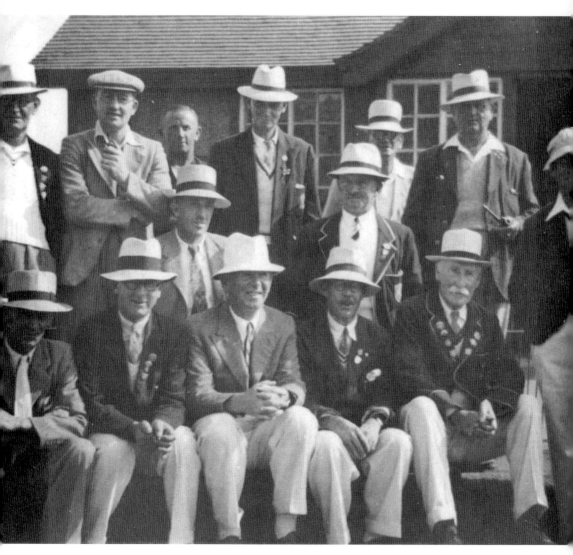

Teignmouth bowlers, 7 September 1940. Included here are Mr Woolley, Mr Brock and Jack Clampit, the greenkeeper in the back row and the only man in the picture without a hat. White panamas seem to be the fashion at the time.

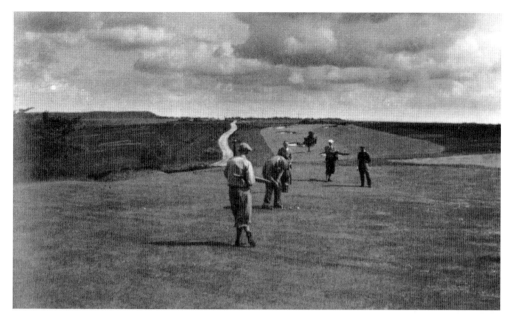

Haldon Golf Club in the 1930s.

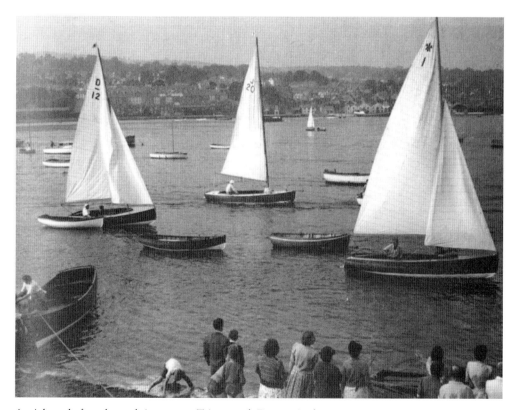

A trial run before the yachting race at Teignmouth Regatta in the 1950s.

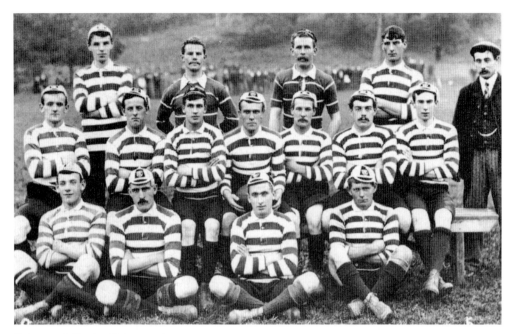

Teignmouth Rugby Club, 1904/5.

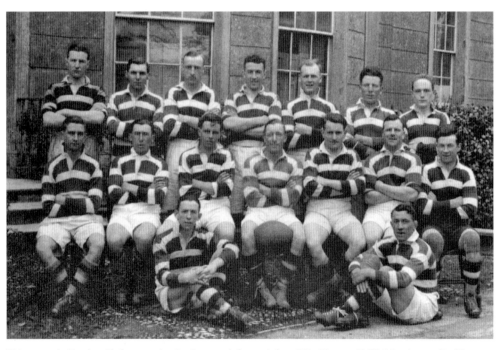

Teignmouth Rugby Club, 1927/8. Back row, left to right: C.E. Young, E.W. Northcott, R. Hooper, R.J. Cousins, W.J. Henley, J. Belton, H.G. Corden. Second row: S.S.E. Lane, W.G. Phillips, S. Apps, J.J. Field (Capt.), W.G. Brewer, G. Cox, C.H. Gilpin. Front row: H. Hooper, G. Rookes.

six

High Days

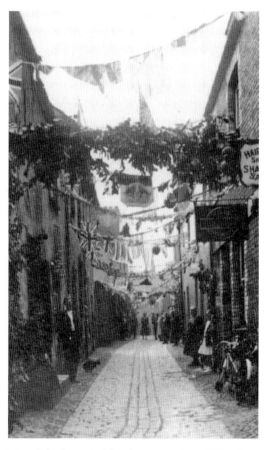

Albert Street, Dawlish, decorated for the coronation of King George VI, 1937.

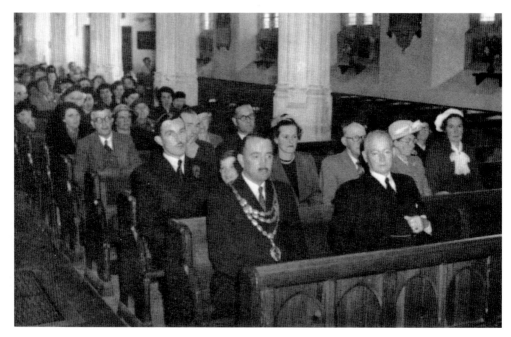

The coronation of Queen Elizabeth II on 2 June 1953 was celebrated in style in Dawlish, as in most towns in the country, and began with a gun salute on The Lawn at 6.00 a.m. At 9.30 a.m. the Revd W. Hammond-Croft officiated at a service at which the combined choirs of St Gregory's and St Mark's took part. Seen here at the service are, left in the front pew, Mr O.J. Eveleigh (chairman of Dawlish UDC), and his vice-chairman, Mr H.B. Hancock.

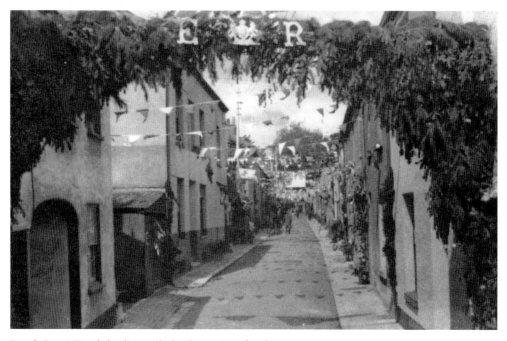

Brook Street, Dawlish, alive with the decorations for the 1953 coronation.

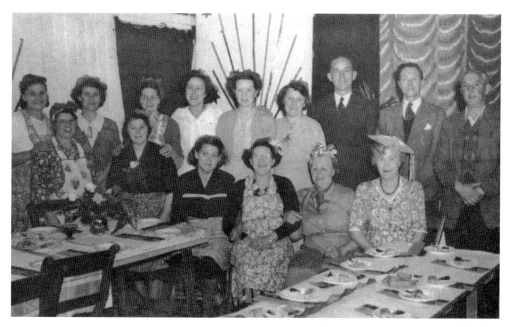

Where would the Royal British Legion be without the Women's Section? Ladies were well to the fore in the preparations for the 1953 coronation dinner at the British Legion HQ (the 'Royal' came later) in Hatcher Street. Among the workers are Mrs Trigger, Mrs Trapnell and Fred Shelston.

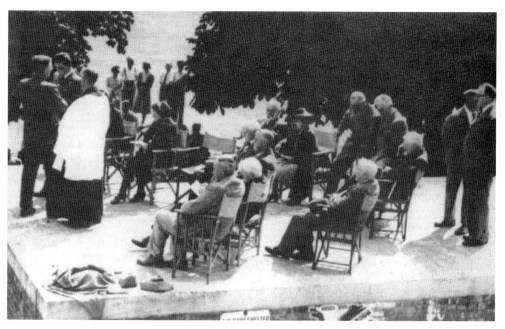

VJ Day celebrations, The Lawn, Dawlish, 1945. An open-air service conducted by the Vicar, Revd G.S. Trewin, was held on the air-raid shelter on The Lawn to offer thanks for the cessation of hostilities in the Far East. The lesson was read by Pilot Officer Geoff Cowling.

Dawlish Carnival, August 1957. The nationally famous comedian Charlie Chester and Carnival Queen Rosemary Lambshead at a Young Farmers ox-roast on The Lawn.

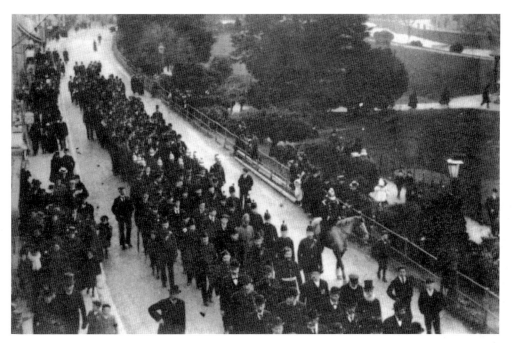

On 2 February 1901, a grey winter's day, a procession marches along The Strand towards the church for a service to mark the death of Queen Victoria. Very few Dawlishians could recall any other monarch, the much-loved Queen having been on the throne since 1837.

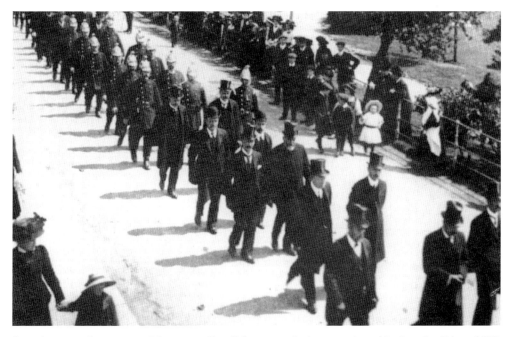

Just nine years later, on 20 May 1910, Dawlish was again in mourning; this time for Edward VII. The Council, superbly dressed, as befitted the town's leading citizens, are followed to church by the fire brigade.

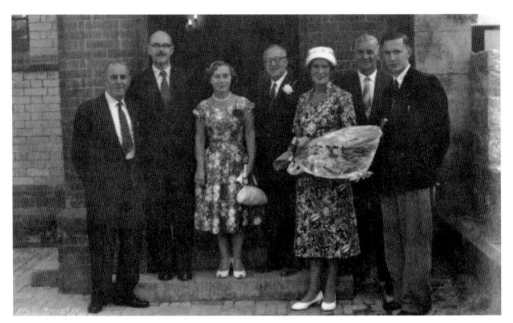

The official opening of the Shaftesbury Theatre, Dawlish, in 1959, by Mrs Margaret Nichole, the wife of the president. The Dawlish Repertory Company began during the winter of 1949/50 and, after some productions at the County Secondary School, used the Hut (see p. 21) until its demise in 1959 when they bought the Shaftesbury Hall and converted it into a theatre. Members here include Bob Hinton, Mr Westcott, Miss Joyce Lamacraft, Jack Shobbrook, Mrs Cockram, Mr Cockram (chairman of Dawlish UDC), and Michael Wedlake.

Burseldon, Dawlish, c. 1948. When Dawlish hospital became part of the National Health Service, a presentation was made to the matron, Miss Cicely Abbey, and the secretary, Miss Jessie Skinner.

The Strand, Dawlish, 1953. A floral dance through the streets was part of Dawlish's celebrations for the 1953 coronation.

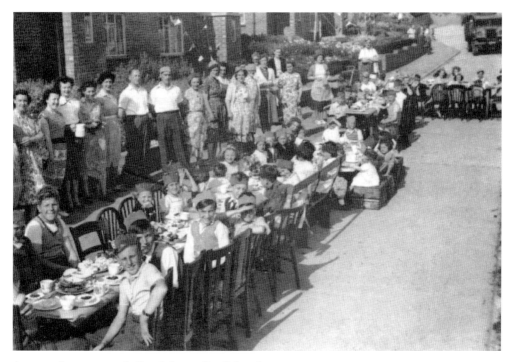

A coronation tea-party in Brook Street, Dawlish, 2 June 1953.

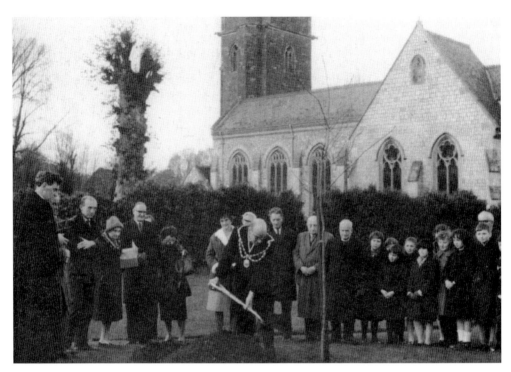

St Gregory's church, Dawlish, Maundy Thursday, 1953. A red hawthorn, given by Mrs Barr, is planted in the churchyard. The vicar, the Revd Delve, and Bill Bryant (on right) look on.

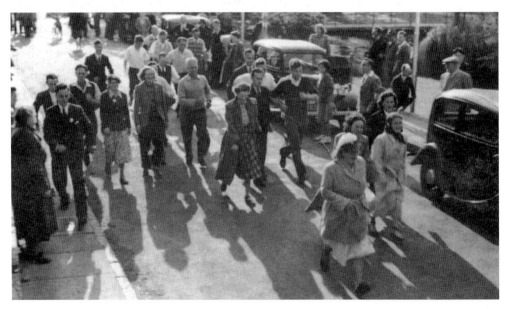

Although the lady in the lead is suspiciously approaching a canter, if not a gallop, this is a walking race for the over-thirties in The Strand during the festivities to mark Queen Elizabeth II's coronation in 1953. Judging by the way the parked cars are facing, two-way traffic was still in operation in The Strand at the time.

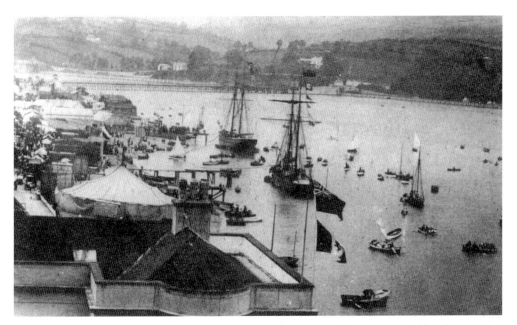

Shaldon Regatta, 1910. Of special interest here is the old wooden bridge, the landing-stages and the almost complete lack of development on the Teignmouth side of the estuary.

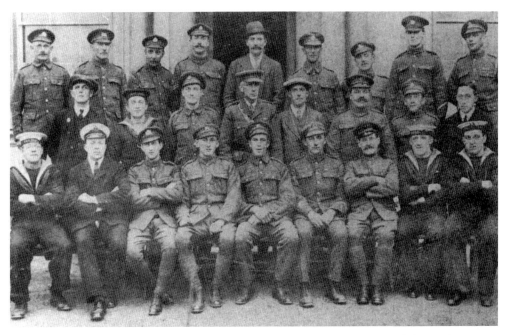

Shaldonians back from the First World War pose at Fonthill in 1919. Back row, left to right: George Price, Bill Winsborrow, Frank Bulley, Bill Passmore, Bill Stone, Fred Mole, Percy Wood, Dick Broad, Sid Sleeman. Second row: Fred Winsborrow, Sid Woolf, Sidney Hosegood, Colonel Duxbury, Jack Lambe, Richard Evans, Bill Cornish, -?-. Front row: Sid Crang, Bert Podbury, Ernie Gooding, Harold Mole, Bill Mole, Lawrence Mole, Charles Underhill, George Tothill, Jack Tothill.

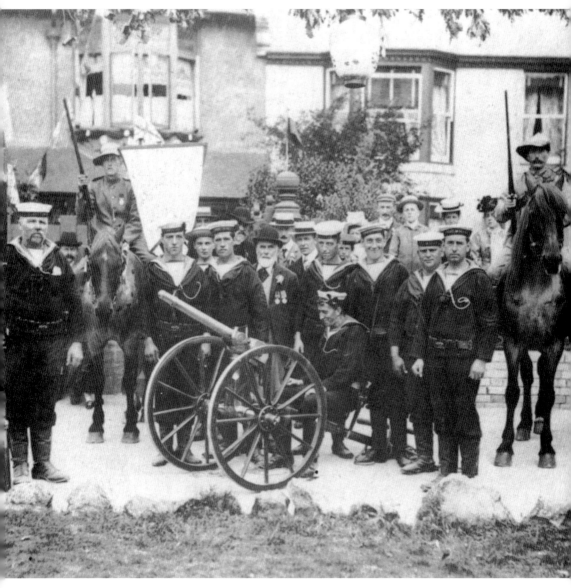

Shaldon Coastguard on parade outside Red Tiles and Potters' Mooring on The Green during the celebrations for the coronation of Edward VII in 1902. Charles Henry Wyatt, standing to attention with the rifle on the left, was the Chief Boatman of the Coastguard. Among the others are, left to right: First Sailor Mr Leslie, Second Sailor Mr Brockenshire, William Wood (with his medals; one of the three butchers in the village at the time), and Mr Tothill (seated by gun). The three horsemen, including the Payne brothers on the right, are thought to have just come home from the Boer War.

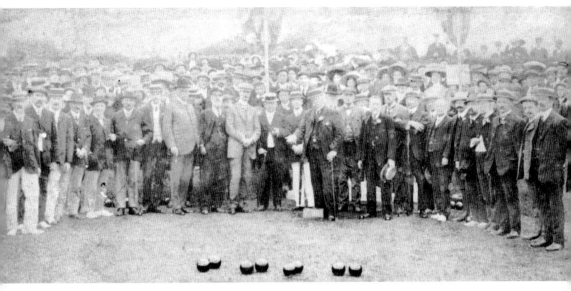

Not without good reason, towns that depend on the holiday-maker, or tourist in today's language, are quick to realize the value of 'attractions', a fact no doubt appreciated by the crowd gathered to celebrate the opening of Teignmouth bowling-green in 1909.

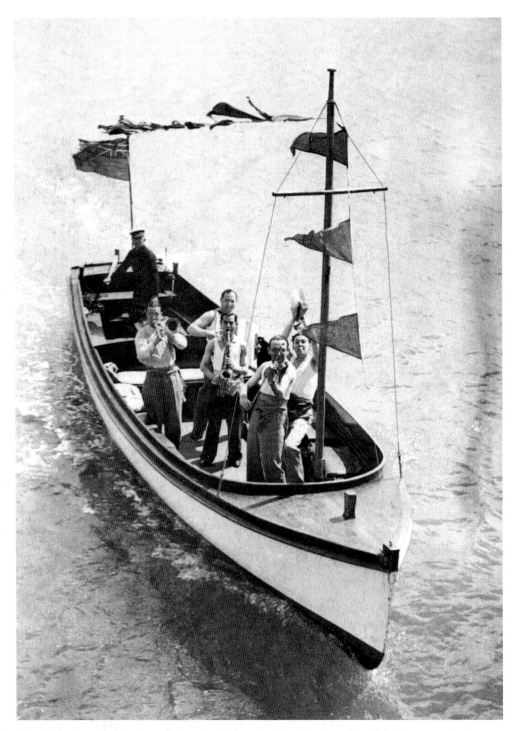

Possibly a Teignmouth Regatta, *c.* 1937, with five men playing music aboard the Teignmouth pleasure boat *Sea Hawk*, (Skipper Bill Matthews). The musicians may be the Mas Recrap Band from the Den Bandstand.

seven

Beside the Seaside

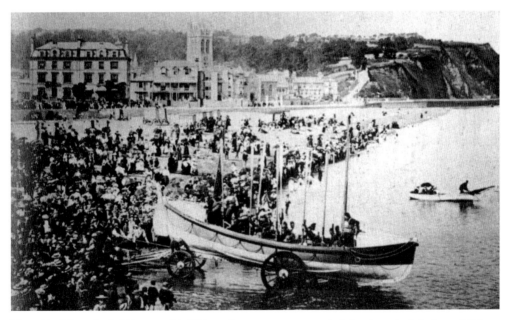

The *Alfred Staniforth*, Teignmouth's lifeboat from 1896 to 1930, is being launched during a Lifeboat Week, *c.* 1929. The boat was purchased through a legacy of Mrs Staniforth, a Sheffield lady, and saved sixty-four lives during its time at Teignmouth. A lifeboat was established in Teignmouth in 1851 and taken over by the RNLI three years later. The station closed in 1940, the lifeboat (the *Henry Finlay*) remaining in the boat-house during the war years. The station, now with inshore lifeboats costing £60,000 compared to the £124 for the 1851 boat, re-opened in 1990.

The main beach, Dawlish, 1869. Fishing boats used to be drawn up on the main beach as well as at Boat Cove, and here it is possible to see the nets drying in the sun as well as the early bathing machines.

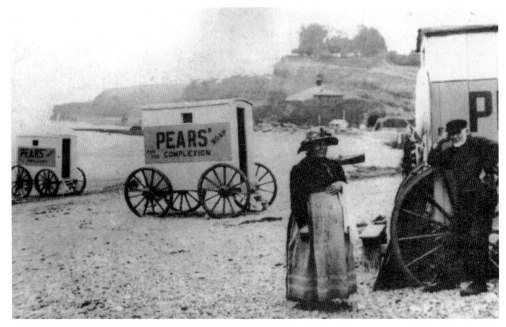

The main beach, Dawlish, c. 1908. By now someone had realized the advertising potential of the bathing machines, which could be wheeled right down to the water's edge to save the more modest bather walking up the beach. Despite the lack of bathers, the trees just visible on the hill behind suggest that it is summer but, if so, no amount of sun is going to make Mrs Mary Anne Coombs cast a clout, even if May is out. She and her husband, Henry, who was always known as 'The Admiral' and is seen on the right, ran the bathing machines and were two of Dawlish's best known characters.

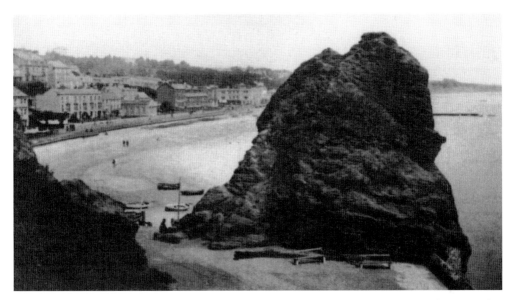

The Red Rock, Dawlish, *c.* 1890. The biggest difference between this picture and one of today is that the top of the Red Rock, one of Dawlish's most well known attractions, is now much flatter.

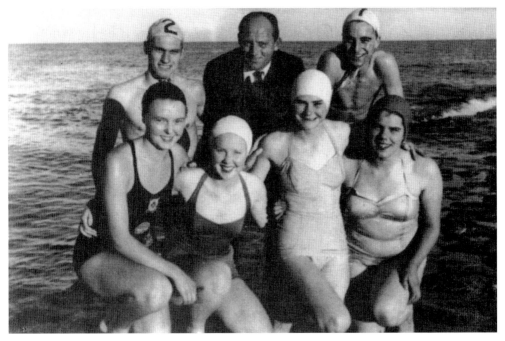

Members of Dawlish men's polo team and ladies' Swimming Club, including Miss Sutton, Mr Gough and Mr Trapnell, pose together in 1957. This is a far cry from 1864, when Dawlish was the first town in South Devon to organize swimming matches, and then just for men as the ladies' heavy serge costumes could only be safely used in shallow water. The men bathed at the men's bathing cove (Coryton), where those who did not own costumes swam in the nude.

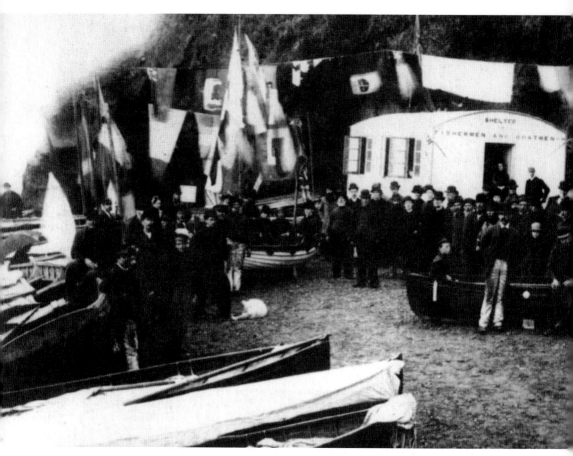

The Boatmen's Shelter, Dawlish, 1886. Fishing was once an important part of Dawlish's economic life and there appear to be around fifty fishermen in this picture, which shows the official opening of the first boatmen's shelter, built at the Boat Cove through the efforts of Miss Flora McDonnell Pearce, who took great interest in the welfare of the Dawlish fishermen. At the ceremony she handed a key to each of the fourteen members of the fishermen's committee. Captain Doxat, RN, thanked Miss Pearce on behalf of the fishermen who, to show their appreciation, drew her to her home in a chaise. A week later Mr J.H. Somerset's fife and drum band marched to the shelter and played a selection of their tunes. By the 1920s there were only six fishermen in the town; today there is not one although, like most Devon seaside towns, Dawlish has an enthusiastic amateur sea-angling community. Going back to the nineteenth century, a Mr R. Tripe of the Gresham Inn (affectionately known as the Greasy Pig), who acted as agent for a London market, would salt any large catches of herring in hampers between layers of bracken and send them by the first goods train to London. In 1910, it was possible to buy twenty herring in Dawlish for 1s.

The Boatmen's Shelter, Dawlish, 1939. This is the third shelter, which was opened in 1937 replacing the second, opened on 16 May 1903 and which had contained a notice saying 'No intoxicants, no gambling'. Of course, in those far-off days smoking was not considered anti-social.

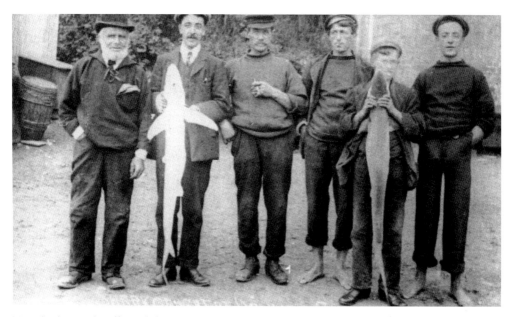

Two sharks caught off Dawlish, 1907. Ernie Cotton, one of the town's last fishermen, is third from the right.

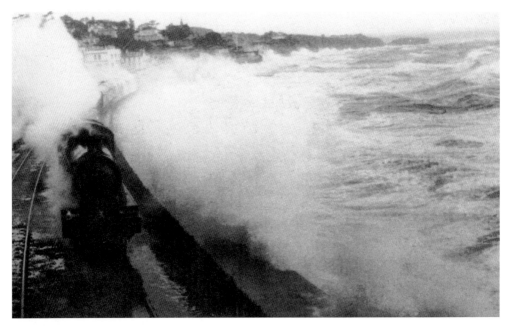

This is a face of Dawlish's sea front that the summer visitor does not often see. Storms, such as the one seen here in 1960 as a Plymouth-bound express makes its way through the waves, were often severe enough for the line to be closed.

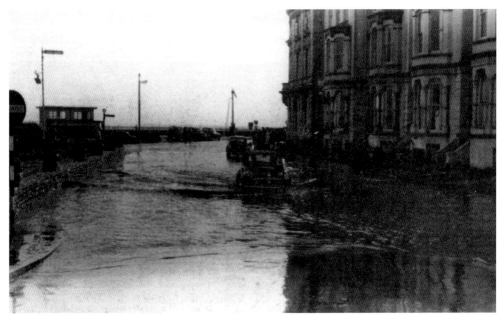

It was in October 1960 that heavy rain on Dawlish's surrounding 'water-shed' hills coincided with a very high tide. Waves flowing under the viaduct pushed the flood water coming down the brook back into the town and flooded the York Gardens and surrounding streets, including these seen at the junction of Westcliff and Brunswick Place.

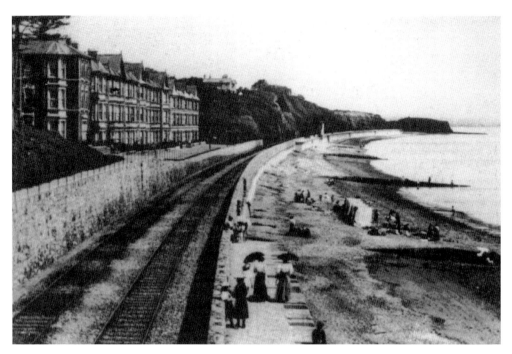

Sea Lawn and Riviera Terrace, Dawlish, *c.* 1905. This part of Dawlish's sea front was not so well favoured by early photographers. This view, labelled 'Family Bathing Place', shows the stretch of beach to the east of the station towards Dawlish Warren.

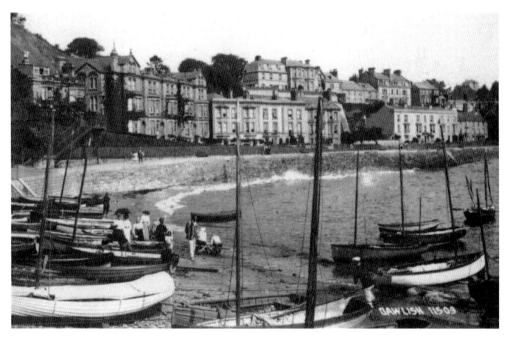

The King's Walk and the main beach, Dawlish, 1908. Note the winches for winding up the bathing machines and the bathing costumes drying on the line.

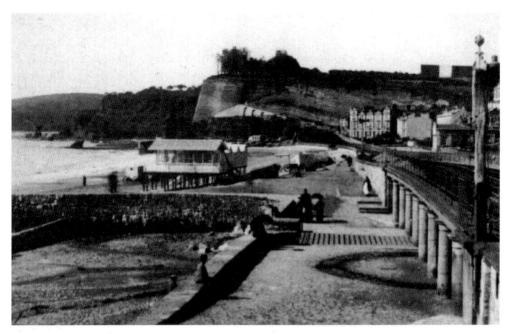

The sea front from the railway station, Dawlish, c. 1893.

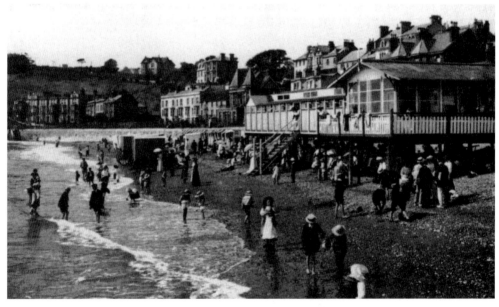

The Pavilion, Dawlish, 1911. The Ladies Bathing Pavilion Company Ltd was formed in 1879 with a capital of £1,000 in one thousand £1 shares, with the GWR granting a lease of a part of the main beach for the site. Inside was a double row of dressing-rooms and a reading room at one end. Once dressed in their costumes, the lady bathers were taken down to the sea in tiny cars (see opposite). The reading room was dismantled after storm damage around 1915, and the rest of the pavilion followed suit in July 1940, when it was thought that it could impede defending troops' line of fire.

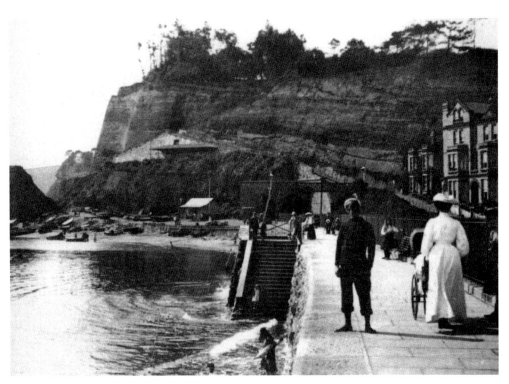

The Boat Cove from King's Walk, Dawlish, 1908. The bare-footed gentleman facing the camera is Ernie Cotton.

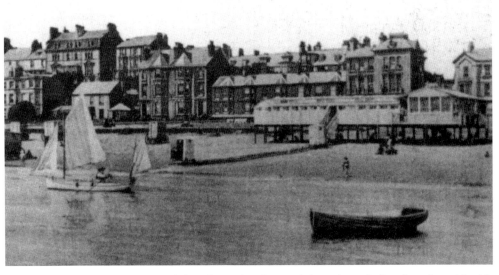

The Pavilion, Dawlish, c. 1890. Little has changed in the Dawlish sea front skyline, but of considerable interest here is the track from the Pavilion, along which bathing machines were drawn down to the sea to 'preserve the modesty' of the lady bathers within. One of the carriages can be seen near the sea.

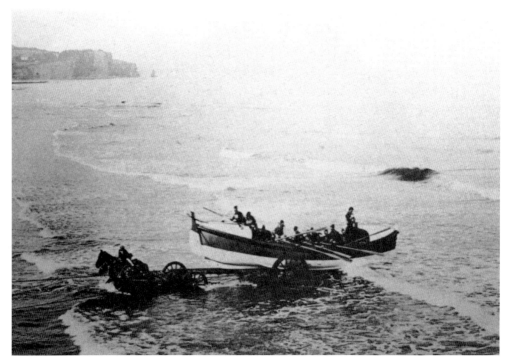

The *Alfred Staniforth*, Teignmouth's lifeboat 1896-1930, is being launched on a carrier, which was pushed into the sea by a pair of horses, *c.* 1910. Today a tractor provides the horsepower.

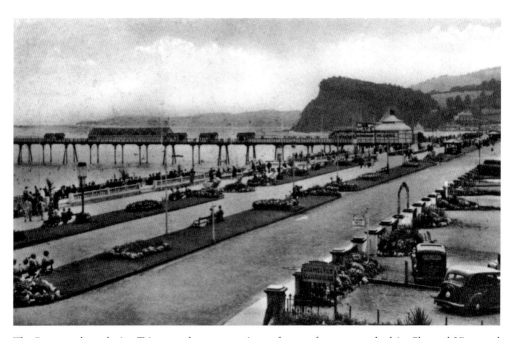

The Promenade and pier, Teignmouth, *c.* 1950. Apart from a few cars parked in Channel View and next-door Seacroft, there is not a vehicle in sight.

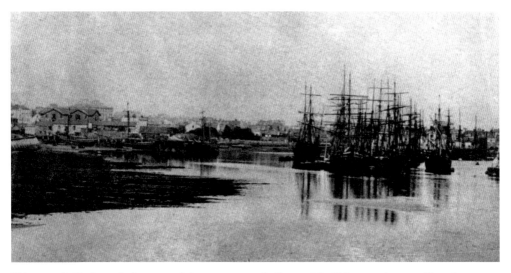

Teignmouth Harbour, before any of the quays were built, *c.* 1860. Teignmouth was still an important port in those days.

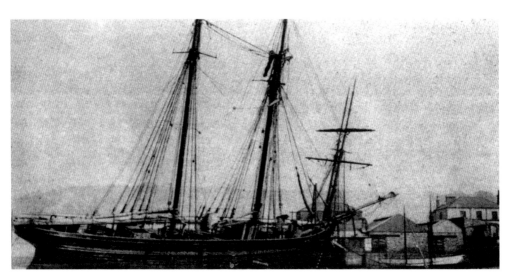

Teignmouth Harbour, with the 'New Quay', *c.* 1900.

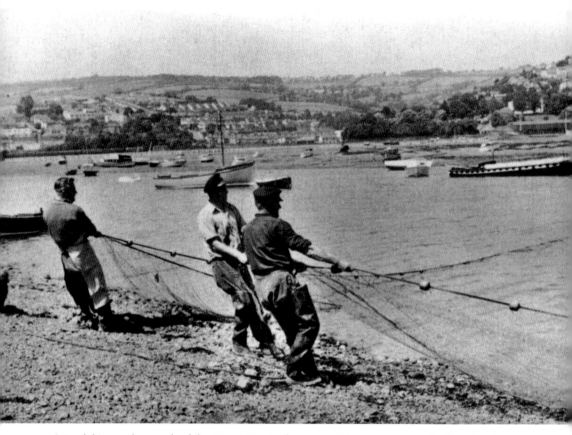

Seine fishing at the mouth of the River Teign in the 1920s. Seine nets were used off the beach to catch mackerel, the net being rowed around a shoal of fish and the ends pulled ashore with the fish trapped inside. As these men are seining inside the estuary, they are probably after salmon.

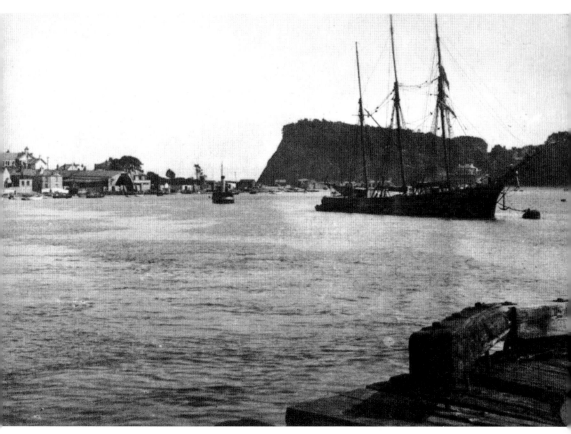

The harbour, Teignmouth, *c.* 1920. Note the old quay, 'Rendle's Quay', on the extreme left, which has now gone.

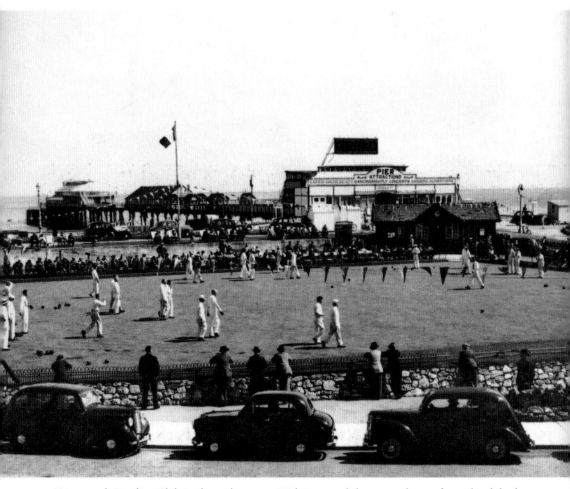

Teignmouth Bowling Club in the early 1950s. With its superb home on the sea front the club always attracts a considerable number of spectators. Of interest here is the old pavilion, replaced soon after this picture was taken by a bigger, if not necessarily more attractive, building and at the end of the pier, in the background, the ballroom, which has been removed.

eight

Transport

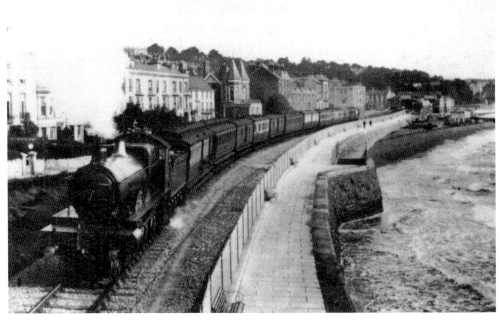

The part of Dawlish most visitors retain in their memories the longest is almost certainly the railway line with its trains running along the beach and shore. Here, in June 1902, the 6.15 a.m. Bristol-Newton Abbot mail train, pulled by GWR locomotive 100 named *Dean*, has just left Dawlish station. Of interest to rail buffs would be the lighter-coloured, fourth, seventh and eighth vehicles which are through-working LNWR vans.

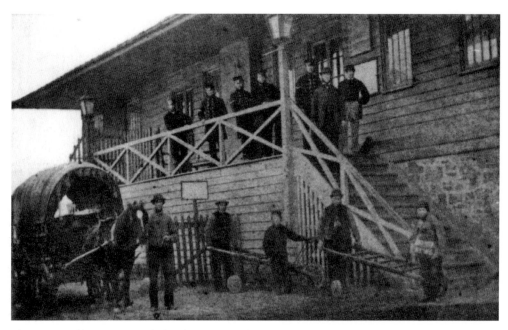

The entire staff were on parade for this picture of the first Dawlish station, which must be dated prior to 1873 because this building, which was erected in 1846, was destroyed by fire in that year. Note the Wild West look of the uniforms, an effect heightened by the delivery van's similarity to a covered wagon.

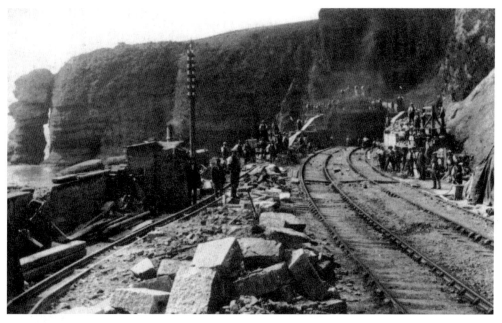

In 1920, the Parson's Tunnel was lengthened by 139 yards on the Dawlish side to prevent damage to the line and trains by cliff falls. Two Dawlish men, T. Currey and C. Moyse, were killed by a passing train during the work.

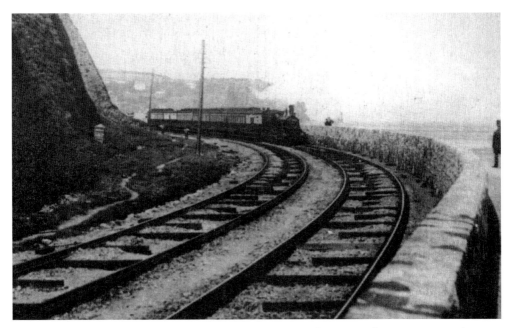

The last broad-gauge train from Paddington to Penzance, seen here on Friday 20 May 1892, between Dawlish and Holcombe. The locomotive is No. 3501, a 2-4-0 tender engine, which took over the train at Exeter. Later it was converted to narrow gauge to work the 'Cornishman' non-stop from Exeter to Plymouth. Of interest here is the fact that every other transom (sleeper) has already been cut to save time when the line is altered to narrow gauge.

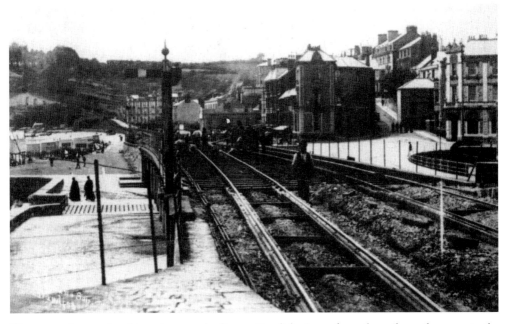

The conversion work taking place on the line at Dawlish. Away from the railway theme, note the complete lack of development on Teignmouth Hill in the background.

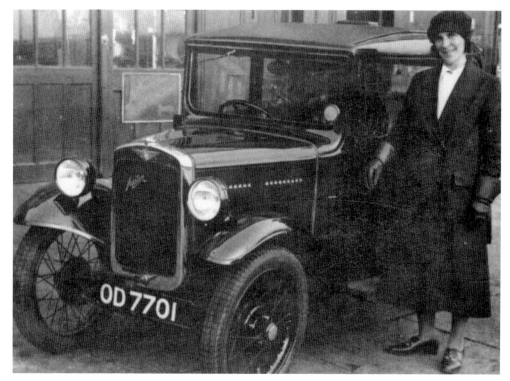

Nurse L. Moore, the district nurse, seen here in January 1934 with her new Austin Seven, a gift from the town to help her carry out her duties. The car cost £118 from Hopkins & Sons' garage, part of the cost being donated by the Carnival Committee.

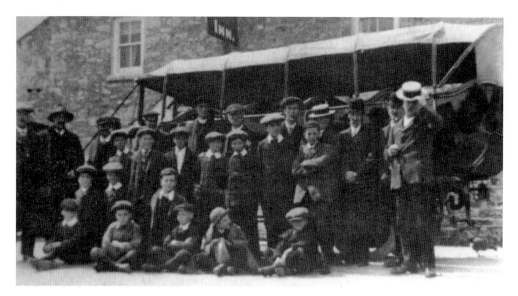

St Mark's (Dawlish) choir stop at the Warren House Inn, Postbridge, on an outing to Plymouth via Dartmoor on 9 July 1921. A photograph showing a charabanc with its canvas roof up, as Shapter's vehicle has here, is a rarity.

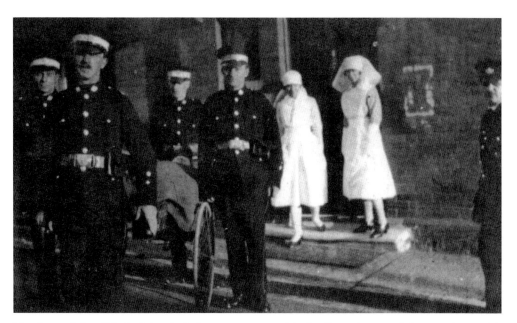

Members of Dawlish St John Ambulance, *c.* 1925, with the litter then used for carrying a sick or injured person to hospital. It was purchased in 1902 with cash left over from the Edward VII Coronation Fund. Fred Bassett is on the right.

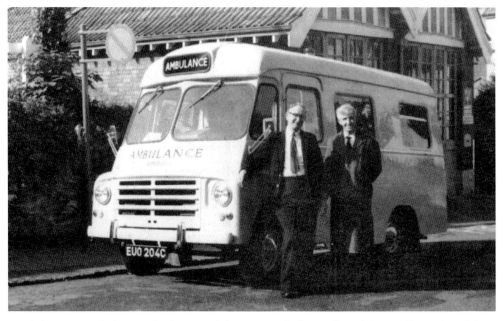

Dawlish motor ambulance. The first Dawlish motor ambulance, the *Edith Cavell*, purchased from Shapter's Garage for £382 in 1930, was housed at the fire station at a rent of a half-penny a year. The second ambulance took over in 1939 just in time for the Second World War. The third, by now costing £1,350, arrived on the scene in 1964 but was quickly replaced by the vehicle seen above. Crew members are Mr Male and Joe Howes.

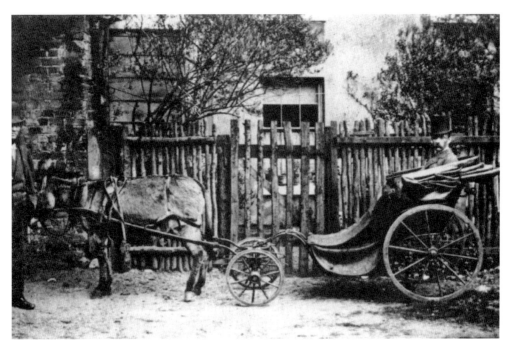

A Dawlish donkey carriage, *c.* 1865.

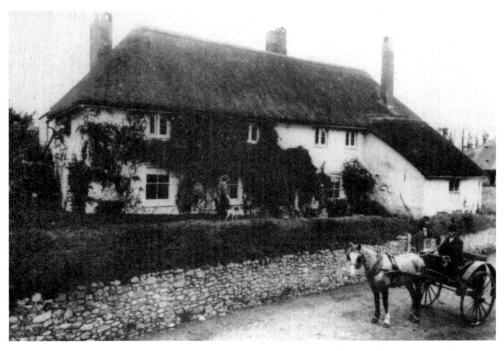

Real horsepower, *c.* 1905. Carell Adams, seen here with his pony and trap, farmed at Langdon Farm (seen behind and destroyed by fire on 18 August 1908). Unlike a motor car, the pony could always bring Adams home after a visit to the hotels in Dawlish – and without any guidance if need be.

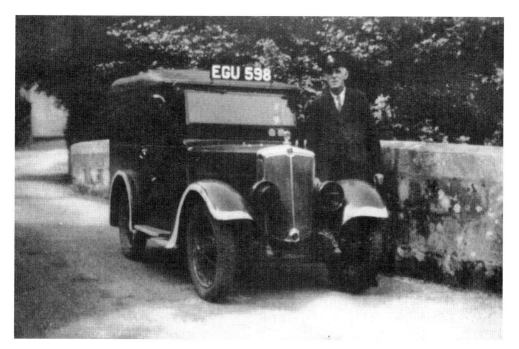

Dawlish post office did not enter the motor age until the outbreak of the Second World War when deliveries to outlying districts began to go by van. Fred Mallett is seen here with one of the first vans in 1941. Note the black-out devices fitted to the headlamps.

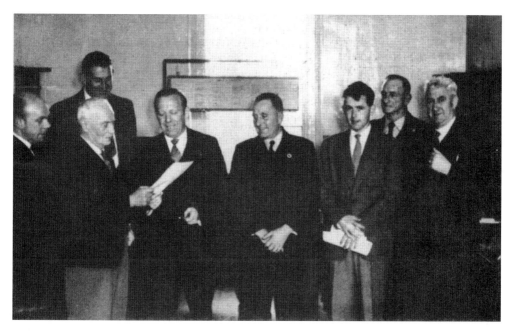

Jack Lamacraft presents some of the Dawlish postmen with safe-driving certificates in May 1957 in the old post office in The Strand. Among the recipients are Roly Hill, Terry Dempsey, Derek Knill and Michael Ford.

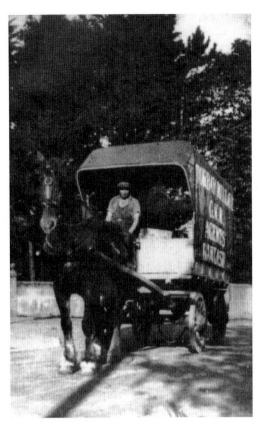

Torbay Mill delivery cart driven by Jack Ware, *c.* 1938. As seen on the side of the cart, Torbay Mill in Brunswick Street was the local agent for the GWR. For details of the mill itself see p. 84.

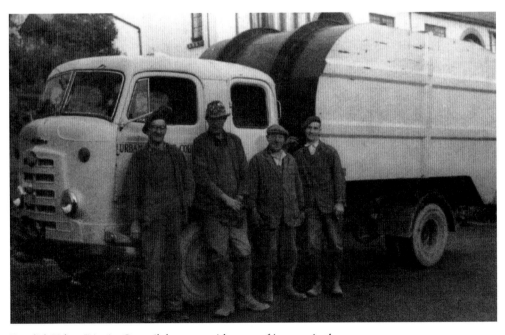

Dawlish Urban District Council dust-cart with some of its crew in the 1950s.

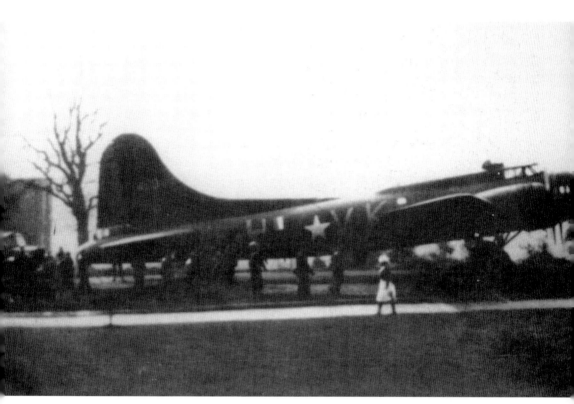

Langdon Hospital, Dawlish, 27 January 1943. A US Army B17 (Flying Fortress), from the 303rd Bomber Group at Molesworth, Hants, lost two engines through flak over Brest. A third engine failed over the Devon coast and, after ordering his crew to bale out, Lieutenant George Oxrider landed his aircraft in a field at Langdon Hospital, Dawlish. Some weeks later, after being fitted with three new engines, the B17 was flown out again. Lieutenant Oxrider, who was later killed on another operation, was decorated for his bravery. Exactly fifty years later, in January 1993, the wireless-operator/air-gunner, who had baled out and landed at Gidleigh on Dartmoor and became a pastor on his return to the USA, made a sentimental return to Gidleigh and Dawlish.

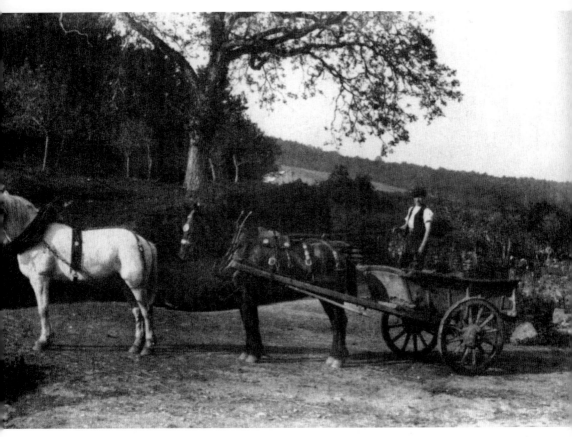

Charlie Smith working at Lidwell Farm, Dawlish, *c.* 1916. The steep hills, 'sidling ground' in the Devonshire vernacular, meant that two horses, as seen here, were often used to pull a cart.

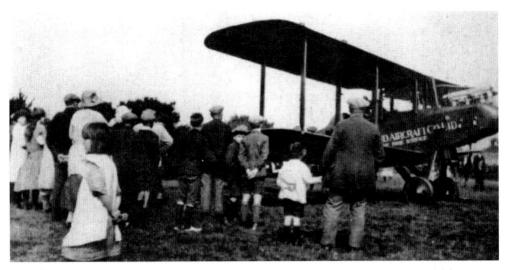

Luscombe Estate, near Dawlish, c. 1923. Even in the 1920s, the early and still-romantic years of flying, it was far from uncommon for aeroplanes to drop in on the grounds of Luscombe Castle, then the home of Sir Peter Hoare. This aircraft was a De Haviland DH 9C, which had landed on the twenty-acre field just behind the area occupied today by the South Downs Road estate. Its pilot was Mr Hubert Broad, De Haviland's chief test pilot, who had flown to Dawlish to collect the firm's chairman, Alan Butler, who had been a guest at the castle.

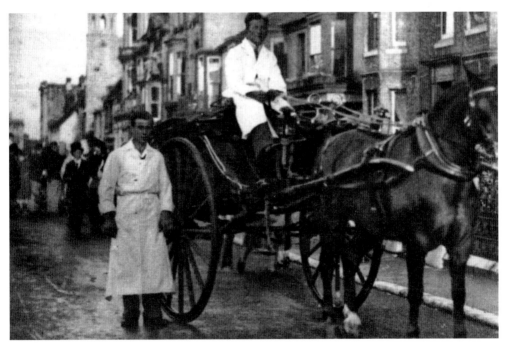

Avery's meat cart, c. 1934. Even as late as the outbreak of the Second World War the horse played an important part in the economic life of the town, especially for street deliveries when only a shake of the reins was enough to get the 'horsepower' moving. Here the cart is about to take part in Dawlish's carnival procession.

The horse's role was not confined to peace-time. Thousands 'served' with the military in the First World War and faced possible death just as much as their human companions. Herbert Thorp is seen here holding the donkey's rein while collecting for wounded horses in Dawlish with two friends.

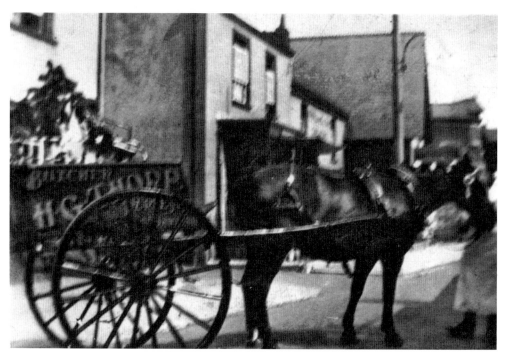

Norman Barton, seen here around 1935, holds Nancy, who pulled the delivery van of H.G. Thorp, the Old Town Street family butchers, for most of her thirty-three-year life.

This Sentinel Steamer locomotive, a '2.4' 1932 model, was used for many years by the Teignmouth Dock Company for moving wagons in Teignmouth Docks. It was bought by Mr Charles Hutchinson, a motor engineer of Redhill, Nottingham, in 1963, to renovate and use in charity and steam-engine rallies.

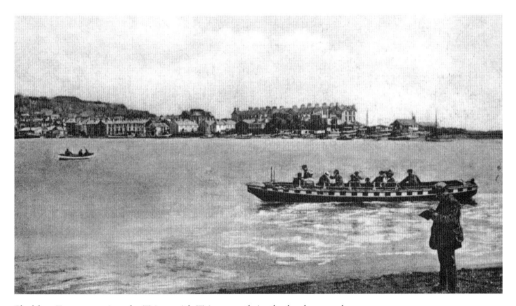

Shaldon Ferry crossing the Teign with Teignmouth in the background, *c.* 1913.

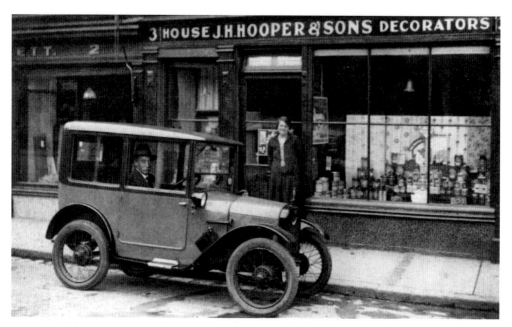

Jack Hooper, seen here at the wheel of his first car, ran his house decorator's business from these premises in Northumberland Place, Teignmouth. Mrs Hooper is standing in the shop doorway. The car, a 1927 or 1928 Austin Seven saloon, enables the picture to be fairly accurately dated.

Teignmouth station, with the Convalescent Hotel just visible in the centre background, during the conversion of the Paddington-Penzance main line from broad to narrow gauge in 1892.

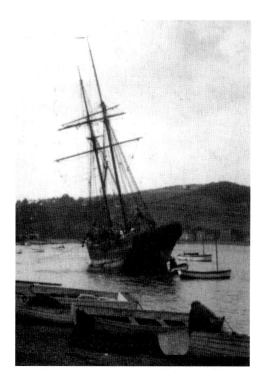

Teignmouth Harbour, *c.* 1923. The vessel moored between Ivy Lane and New Quay is in for repairs to her bottom. Mr Nathan is 'messing about with a boat' in the foreground.

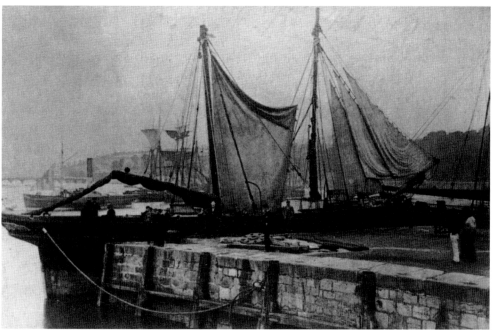

The *Polly Pinkham* seen in Teignmouth Harbour after an epic crossing of the Atlantic from the Rio Grande in 1878. Both masts and her bowsprit were carried away and two men were lost overboard. After discharging her cargo she was towed to Teignmouth for a refit. Two years later she was lost off the Irish coast near Waterford in a snow storm. Five more of her crew perished.

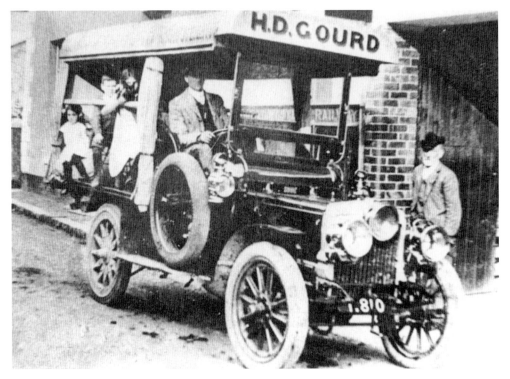

H.D. Gourd operated a bus service from Bishopsteignton to Teignmouth. One of Teignmouth's first buses, a Daimler, is seen here outside Teignmouth railway station in 1921.

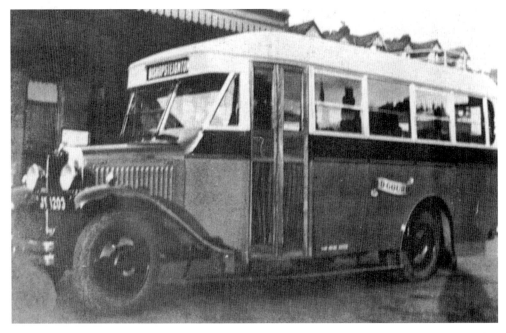

Although still running to Teignmouth station in the 1930s, Gourds have become furniture removers today.

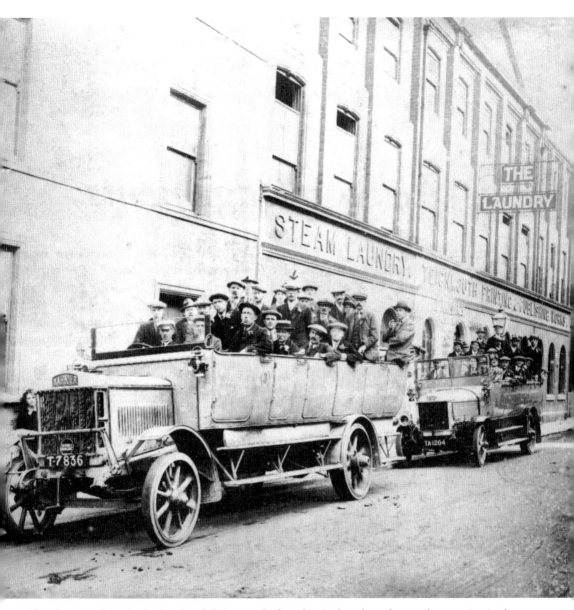

Charabancs arriving in Station Road, Teignmouth, for what is thought to be a railway outing in the very early 1920s. These handsome vehicles, although no longer required to have a man with a red flag walking in front, were nevertheless restricted to 12 miles per hour. The old police station is on the extreme right with the railway station just out of sight beyond that. Teignmouth Printing & Publishing Works became Liptons in later years and today is the Lowcost shop.

Acknowledgements

Without complete access to Bernard Chapman's superb collection of old Dawlish pictures, this book would have been difficult if not impossible to compile. Such is his love of the town his family served for four generations, however, that that access was given to a complete stranger without hesitation, enabling others who love the town to share in the enjoyment of those photographs. And it is not only me, but all who appreciate this collection of old pictures, who owe him a sincere thank you.

I must also thank Anthony Rowland, and recommend his excellent, privately published book *No Epilogue To The Saga*, which movingly tells the story of the Starcross Institution, and Harold Bucklow, not only for access to his lovingly tended Shaldon and Ringmore material, but for much information, including a guided tour of Ringmore's lovely little St Nicholas's church.

The pictures on pages 36-56, 115-16 and 157-9 were kindly loaned by Teignmouth Museum and I must thank Mike Ruddock (curator), Mike Haywood (assistant curator) and especially Nell Plahn (archivist). Every effort has been made, without success, to trace the ownership of the copyright of photographs eligible for the same which have been supplied from the archives of Teignmouth Museum. If anyone knows the identity of the owner, will they please contact the Publisher.

Thanks also go to Paul Barczak, John Godfrey of Seaton Book Centre, Albert Manley, Doreen Ramsenius, Christine Smith and Robin Thorp.